Shame
and the eternal abyss

Shame
and the eternal abyss

Tania Love Abramson

Asylum 4 Renegades Press

ASYLUM 4 RENEGADES PRESS
Joshua Tree, California
asylum4renegadespress.com

A4R seeks daring projects of interest to academic and educated readers.
A4R admires risk-taking authors who write with intelligence and grace
while remaining self-effacing and wryly humorous.

Tania Love Abramson
50yrslater.com

Cover Art and Book Design
Tania Love Abramson

First Edition

praise for **Shame and the eternal abyss**

"A powerful and moving account, visual and verbal, of the ravages of childhood abuse and of the journey of one who saw her way to a life beyond shame and the eternal abyss. Compelling art and poetry."

> — **Elyn Saks,** Orrin B. Evans Professor of Law, Psychology, and Psychiatry and the Behavioral Sciences, University of Southern California. A MacArthur Foundation Fellowship recipient and author of the award-winning book, *The Center Cannot Hold: My Journey Through Madness.*

"Spectacular, profound, visual and verbal expression of the agony of childhood sexual victimization and the lifetime of suffering it can spawn. Yet through the art, we also see transcendence."

> — **Joan Meier**, J.D., Founder and Legal Director, Domestic Violence Legal Empowerment and Appeals Project, and Professor of Clinical Law at George Washington University Law School, Washington, D.C.

"A mesmerizing piece of work, this unique book allows the reader to access a very subjective account of the everlasting double penalty faced by victims of sexual abuse. It also offers, almost unbeknowingly, a powerful gendered critique of victim shaming and blaming. Last but not least, it echoes our societies' vast abysses created by the patriarchal blindness of law. Definitely a new addition to the ideal alternative reading list of critical criminal lawyers and legal scholars."

> — **Dr. Bérénice K. Schramm**, legal philosopher, Cédim, Université du Québec à Montréal (UQÀM)

"To read this book is to experience the struggle to breathe in a world that demands victims' silence. But in the very moment one feels overwhelmed, the words and art put human resilience on full display."

> — **Meg Garvin**, M.A., J.D., Executive Director of the National Crime Victim Law Institute, and Clinical Professor of Law, Lewis & Clark College, Portland, Oregon

"A powerful personal story of betrayal, the lasting damage it causes, and the struggle for recovery, told primarily through the author's haunting artwork. No one can continue to look the other way when adults abuse children (or fail to protect them) after experiencing the impact through Tania Abramson's eloquent rendition of pain."

> — **Catherine Ross**, J.D., Professor of Law, George Washington University Law School, Washington, D.C.

"This is a remarkable book, well-nigh unclassifiable. In it the author opens up a fresh and demanding approach to sexual violence, pouring her wealth of experience into art. It is both helpful and hopeful!"

> — **Dr. Sólveig Anna Bóasdóttir**, Professor of Theology and Religious Studies, the University of Iceland

"Visceral, hypnotizing, corporeal, and courageous sketches of a dark world. Her voice is clear and embodied as it reverberates from the center of a spiraling chaos of shame. Respite is in the doing."

> — **Bianca Sapetto**, performer and choreographer, formerly of *Cirque de Soleil and Teatro Zinzanni*

"Courageous and artful self-inquiry from a woman with a mission, making the invisible world of despair and shame visible."

> — **Dr. Bernet Elzinga**, Professor of Stress-Related Psychopathology, and co-founder of the Child Abuse and Neglect minor program, Leiden University

"Through her eye-catching art work, Tania Abramson managed to express the impact of child sexual abuse as well as chances for reprocessing. This book goes beyond words and is an opportunity for both professionals and survivors to comprehend the dynamics of shame related to sexual abuse."

> — **Dr. Iva Bicanic**, clinical psychologist at the Sexual Violence Center at the University Medical Center Utrecht, and Head of the National Psychotrauma Center, the Netherlands

"Tania Love Abramson's visual-verbal poem draws us in to dark places we hide from (because she learned not to hide from hers), not a pleasant path, but because she gets so far into those places we start to realize that we can move through them. The sequence of images and narration (of her history and experience, not simply of the drawings) eventually conveys progress, progression, even though without providing deliverance. The work is an arresting combination of accessibility, honesty-with-oneself, and courage-to-face."

> — **Dr. Gregory A. Miller**, Distinguished Professor and Chair, Department of Psychology, University of California, Los Angeles

"Very powerful artwork that helps others see and understand."

> — **Dr. Lenneke Alink**, Professor of Forensic Family Studies, and co-founder of the Child Abuse and Neglect minor program, Leiden University

"In our culture, child sexual abuse thrives in the shadows of secrecy. This poignant, powerful, poetic expression of shame reveals an important truth: when we give voice to child sexual abuse, what other people witness is our courage. And when we are seen – truly, safely seen for the parts of ourselves that we love and the parts that hold the most pain – our shame can shift and we can see what other people see in us: bold, beautiful courage."

> — **Kerry Naughton**, Executive Director of Oregon Abuse Advocates and Survivors in Service, Portland, Oregon

praise for *Abyss #14: Purple Rain*

"When one speaks of abuse and neglect, there is a knowing, and, at the same time, a parallel silence of unspoken knowledge. Words, ideas, thoughts, and emotions are shadowed in references, allusions, body codes, and eye gestures.

Tania's art has the ability to convey the hard and the soft, the seen and the known.

The art is communicating nuances within itself and to the audience. Words disappear, and, like the rain that mutates the marks, the messages are conveyed from one to another...where healing begins: from the inside out."

> — **Ellen e Baird**, Professor of English, Copper Mountain College, and Editor, *Howl Art & Literature Magazine*, Joshua Tree, California

dedication

for my husband Paul,
for knowing how to pull me out,
and for his acceptance, love and support

always and forever

contents

a few thoughts on shame

We've all experienced shame at some point in our lives – a deluge of disgrace, engulfed by humiliation, tormented by a great force of internalized contempt.

We compare ourselves to a personal code of ethics or to societal standards more generally. Convinced we have transgressed, shame turns inward – I am bad; I am worthless; I am a mistake.

For some of us who have been victimized by a traumatic and stigmatizing event such as rape or child sexual abuse, a torrent of shame can be triggered by trivial matters – a misspoken word to someone we love, for example. Then the punishing begins as we spiral into a cycle of anguish and misery.

Shame keeps us from living our truth, our authentic selves. We hide in the shadows with our masks of perfection disguising our self-abasement, obscuring our vulnerability. We cope through distraction and denial, or walk through the world as wounded birds, never getting far off the ground.

Dissociation, a coping mechanism experienced by many victims of severe trauma and often accompanied by Post-Traumatic Stress Disorder (PTSD), can be an aftereffect of shame too – a debilitating way of escaping pain, humiliation, and stigma – you are there, but not there.

What follows is how I withdrew from the world.

what are you so ashamed of?

Dissociative Experiences Scale - II

Some people have the experience of feeling that their body does not seem to belong to them.

Circle the number to show what percentage of the time this happens to you.

0 10 20 30 40 50 60 70 80 90 100

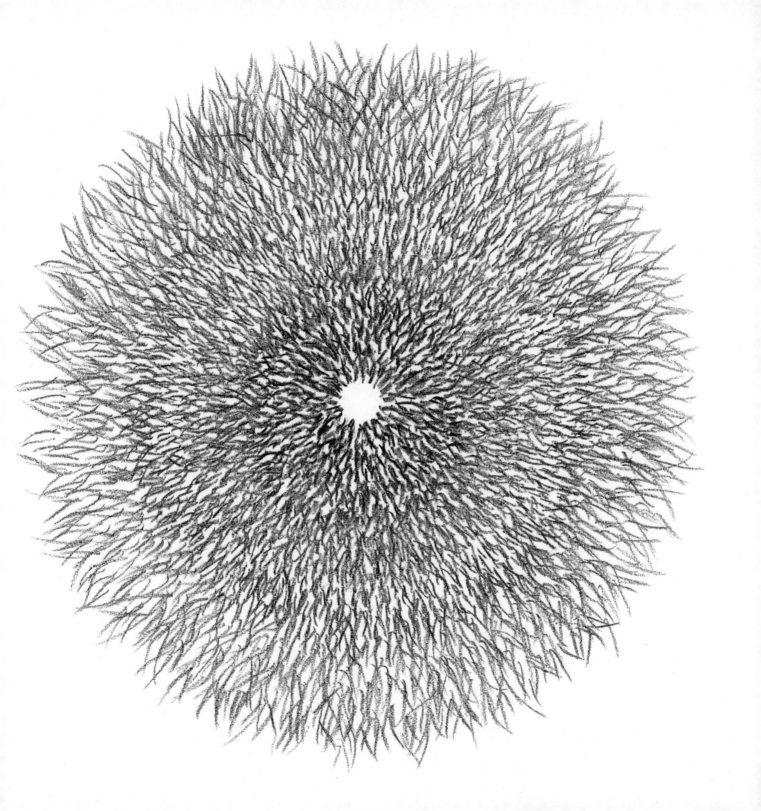

Some people sometimes have the experience of feeling
as though they are standing next to themselves or watching themselves do
something and they actually see themselves as if they were looking at
another person.

Circle the number to show what percentage of the time this happens to you.
0 10 20 30 40 50 60 70 80 90 100

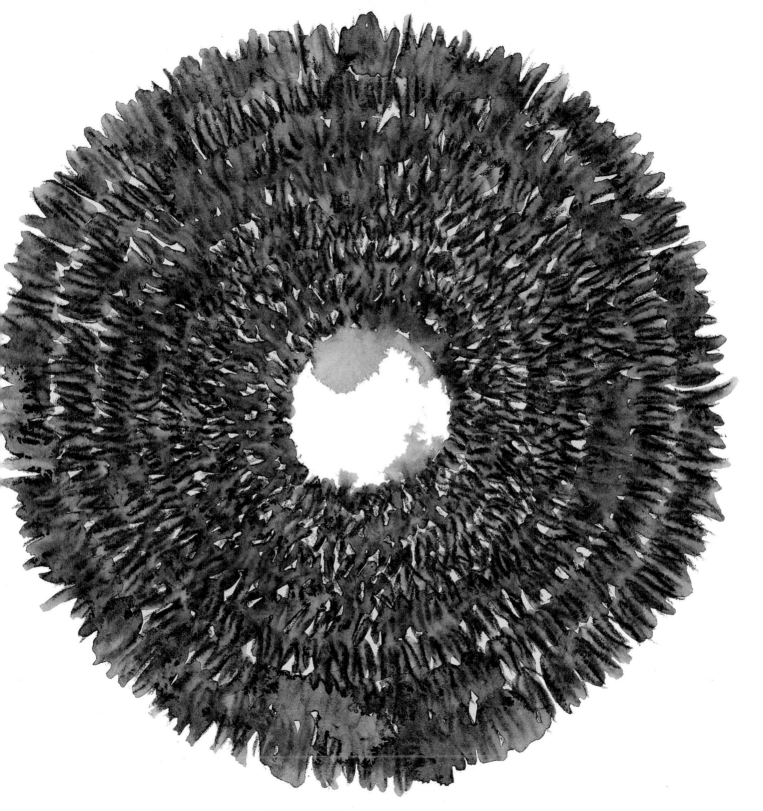

Some people sometimes feel as if they are looking at the world through a fog, so that people and objects appear far away or unclear.

Circle the number to show what percentage of the time this happens to you.

0 10 20 30 40 50 60 70 80 90 100

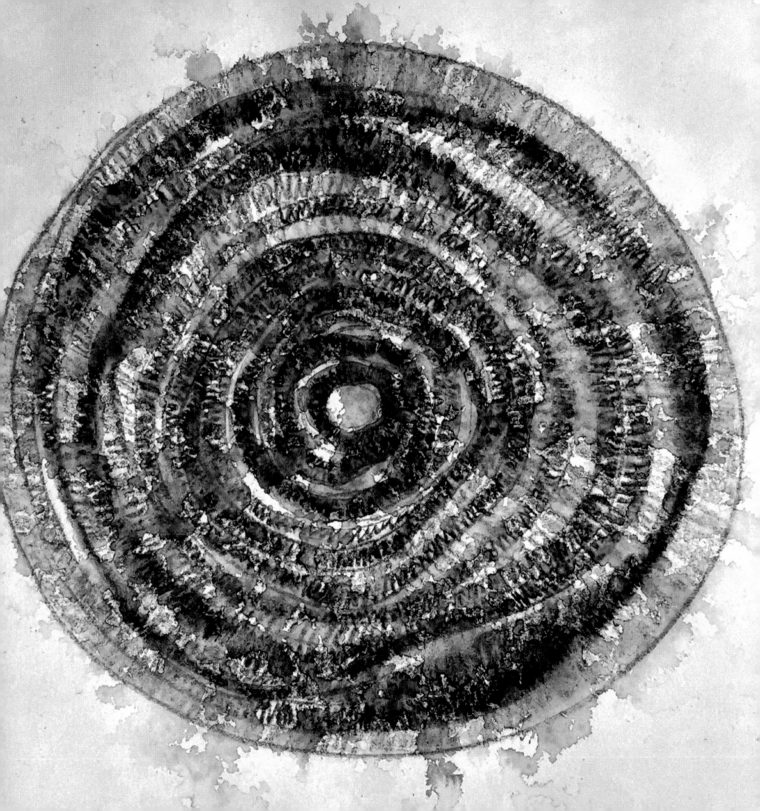

CRAWLING

ACROSS

BROKEN

GLASS

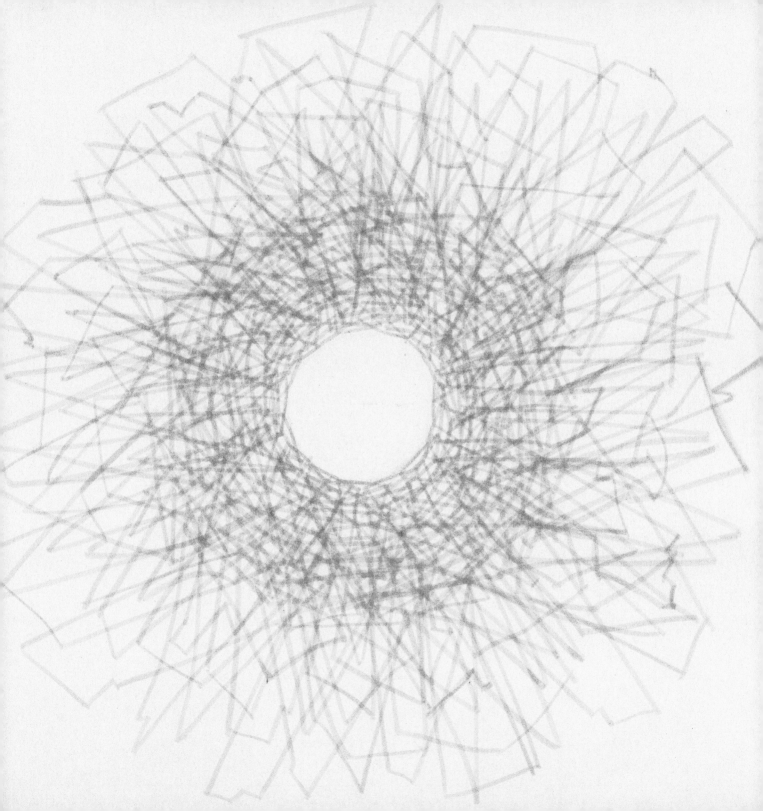

Falling

into

a Sea
of Despair

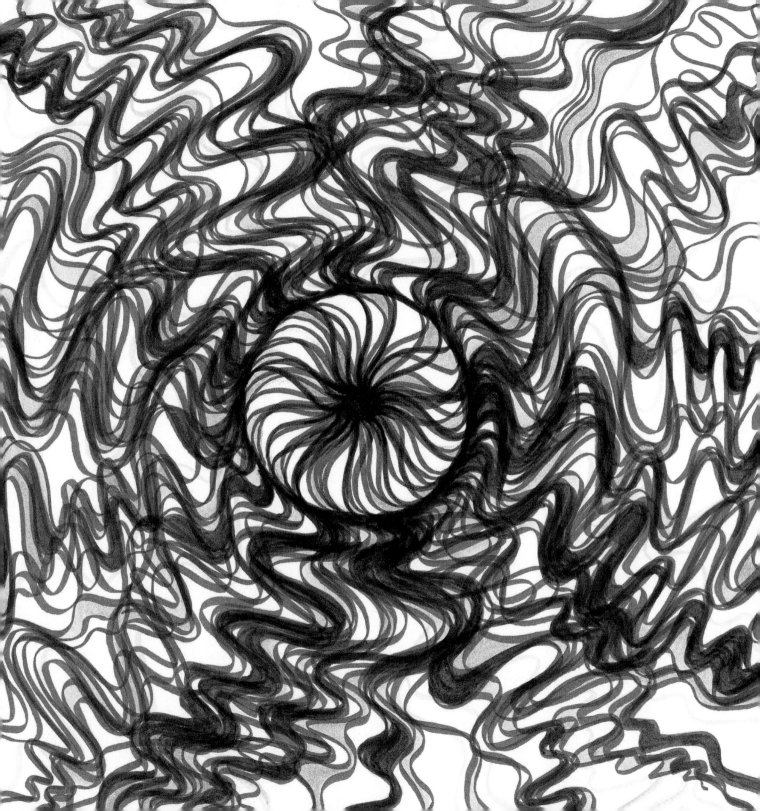

Screaming

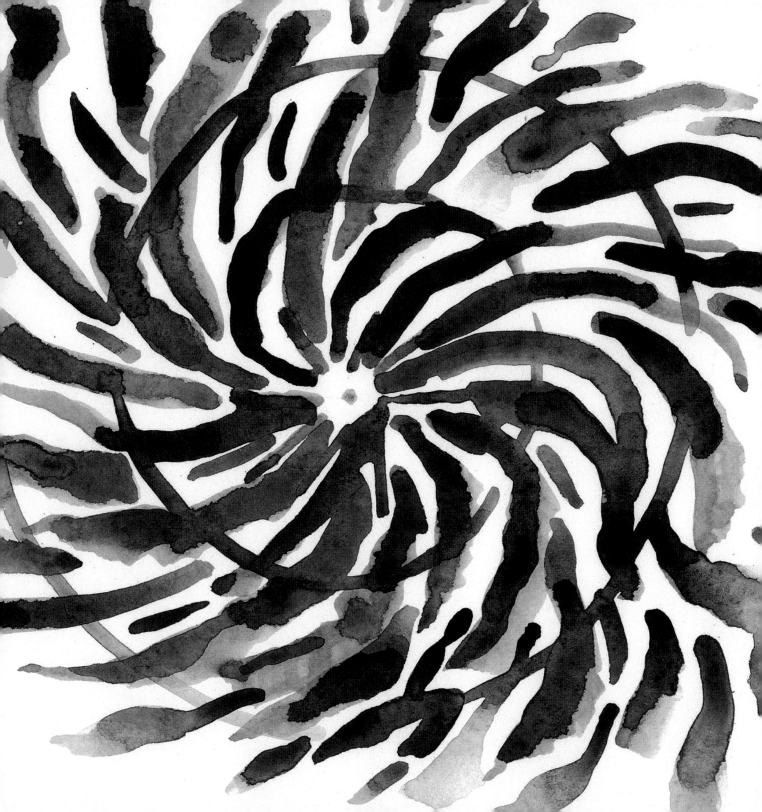

I'm screaming

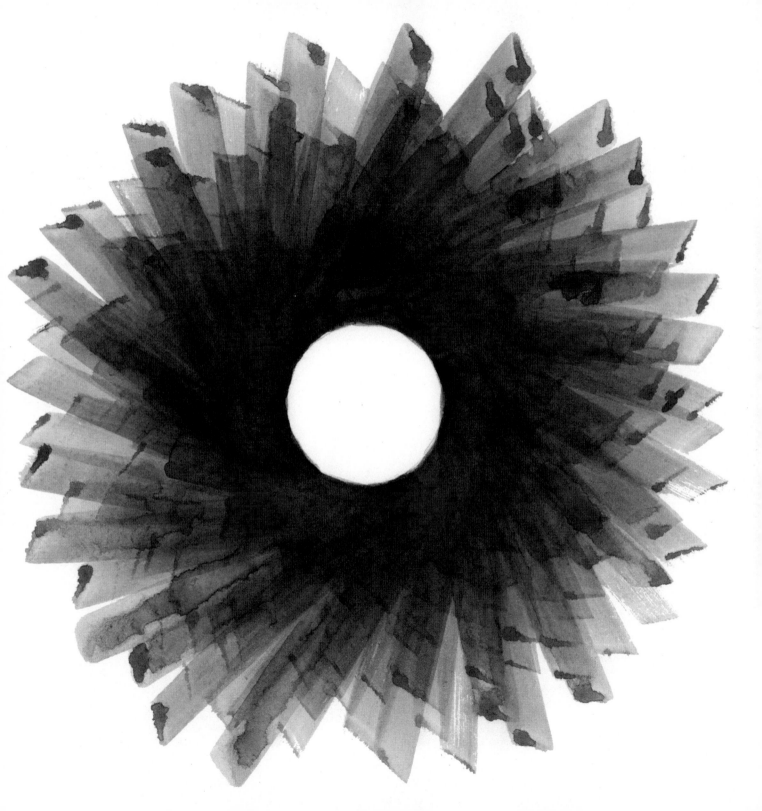

I'm screaming inside

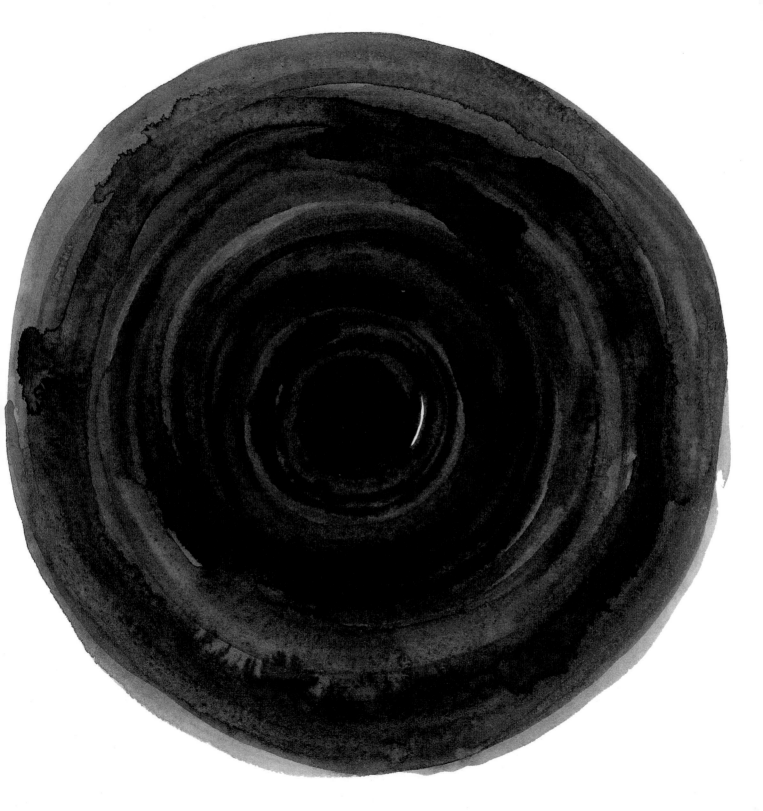

Can't you see?

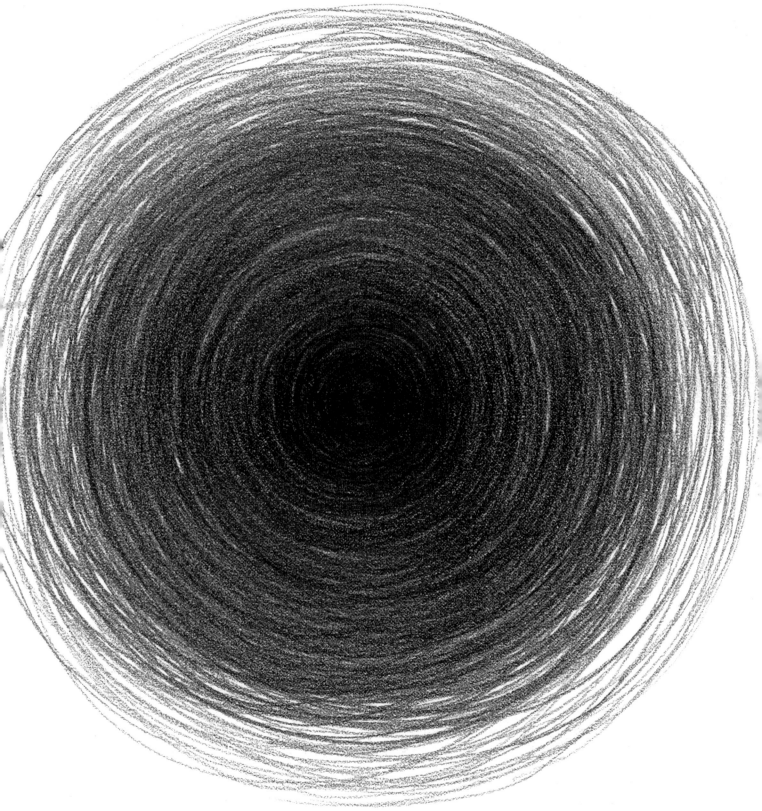

Can't you see me?

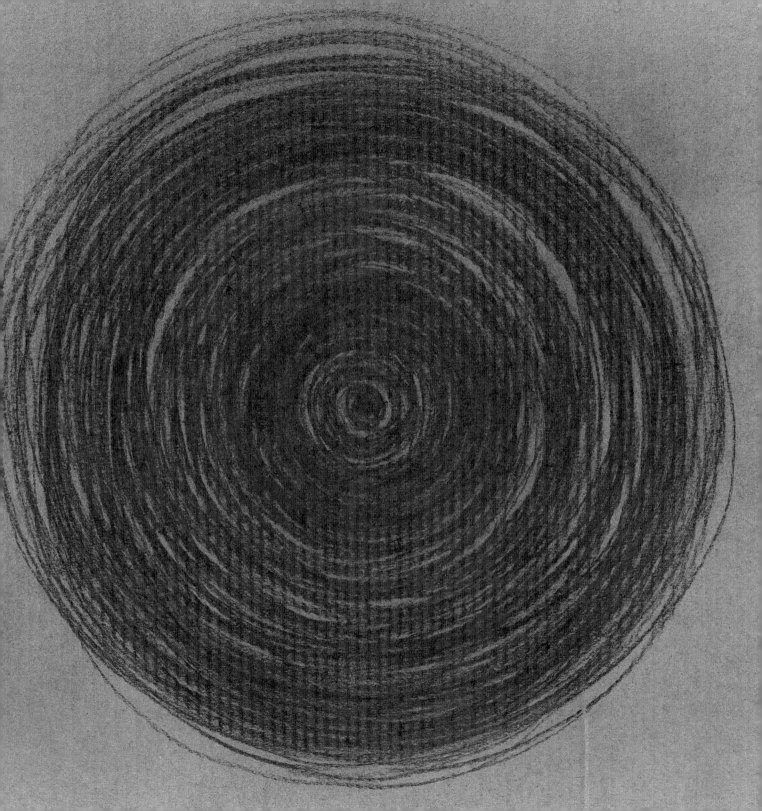

Can't you see me screaming?

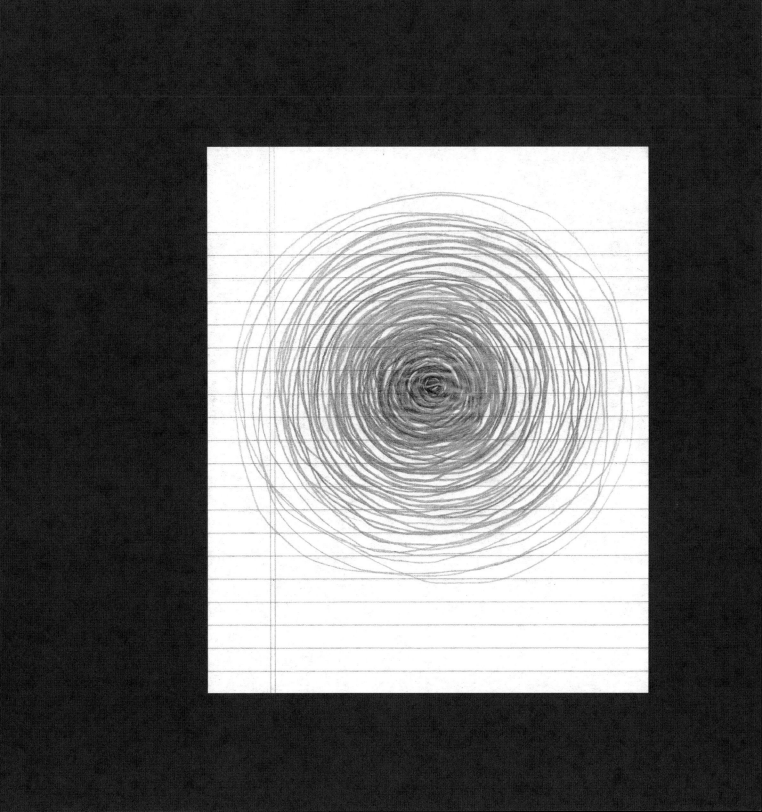

Can't you see me screaming inside?

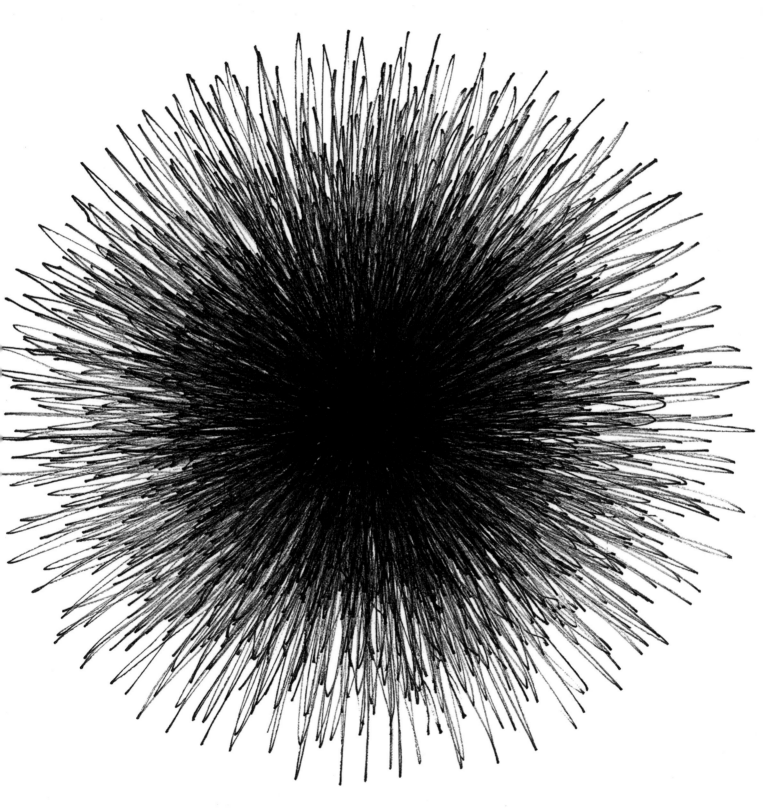

Can't you hear?

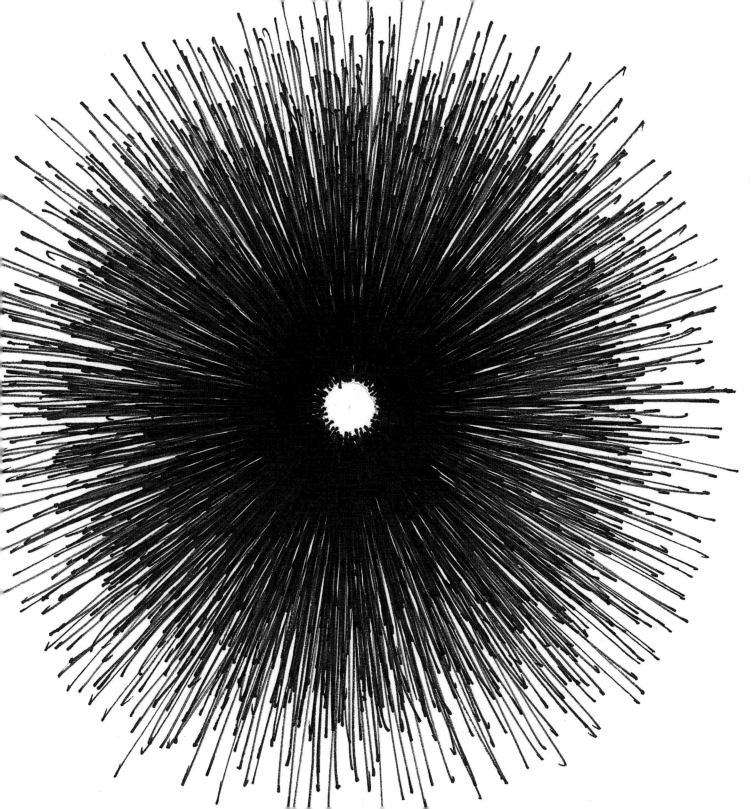

Can't you hear me?

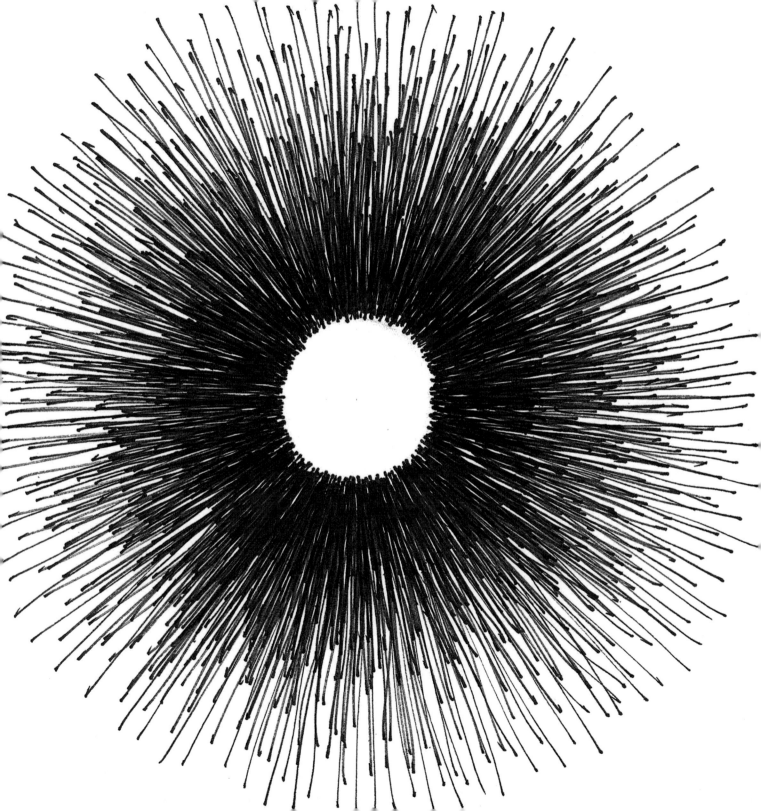

Can't you hear me screaming?

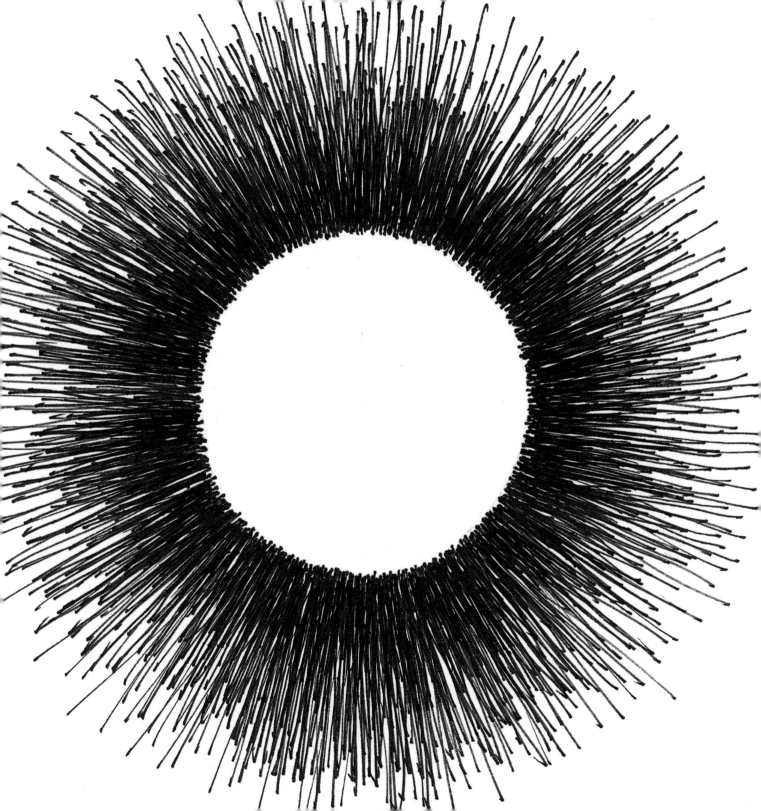

Can't you hear me screaming inside?

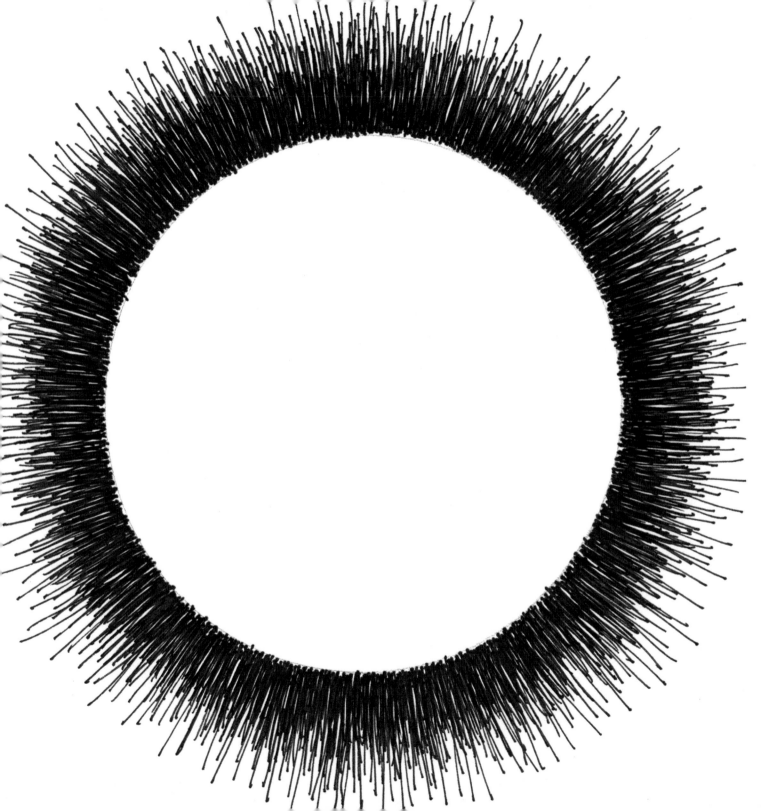

Don't you know?

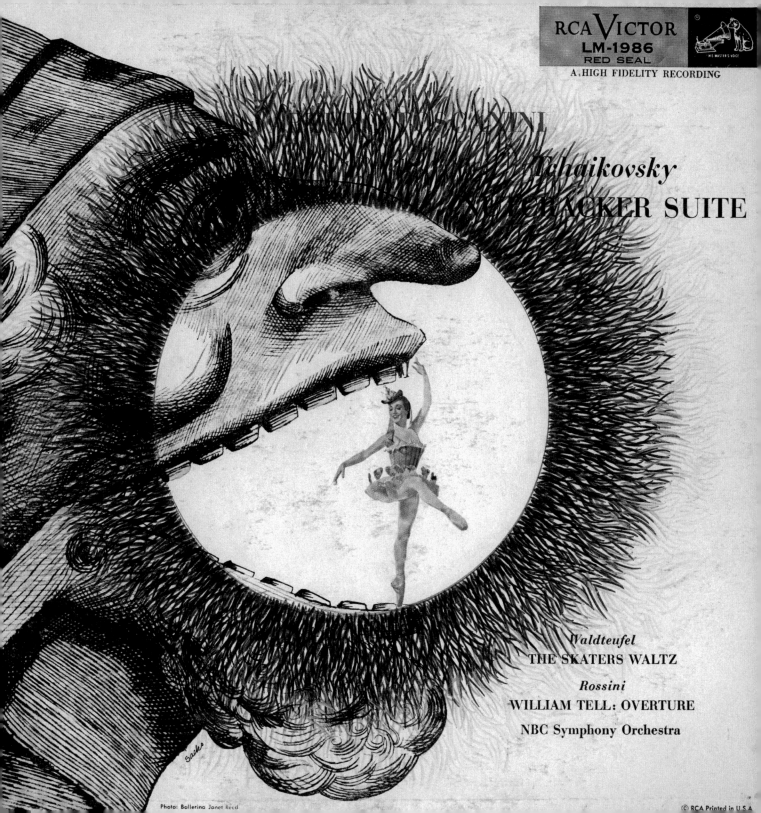

Don't you know me?

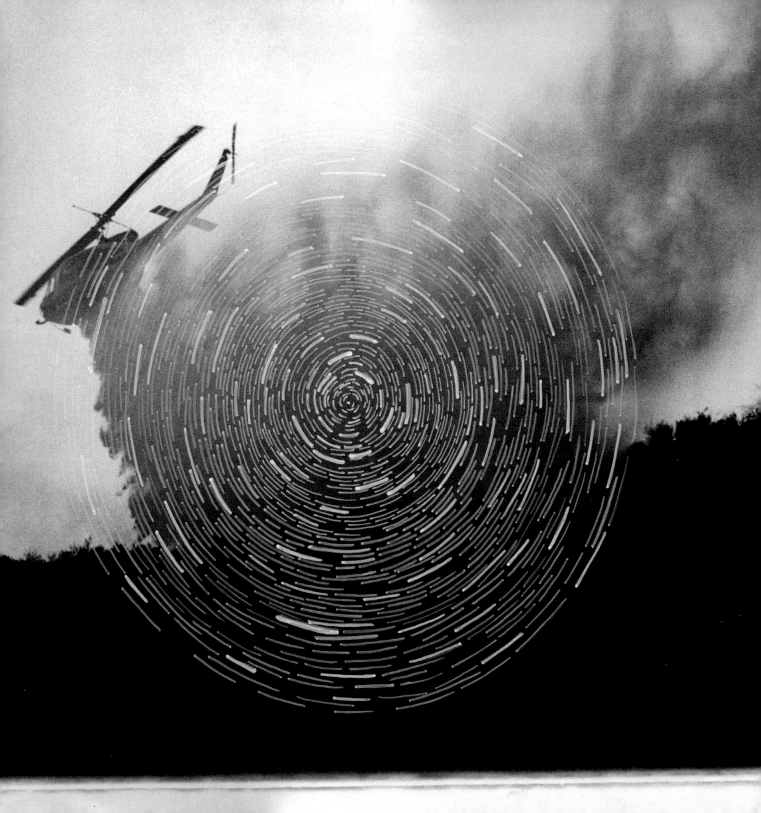

Don't you know I'm screaming?

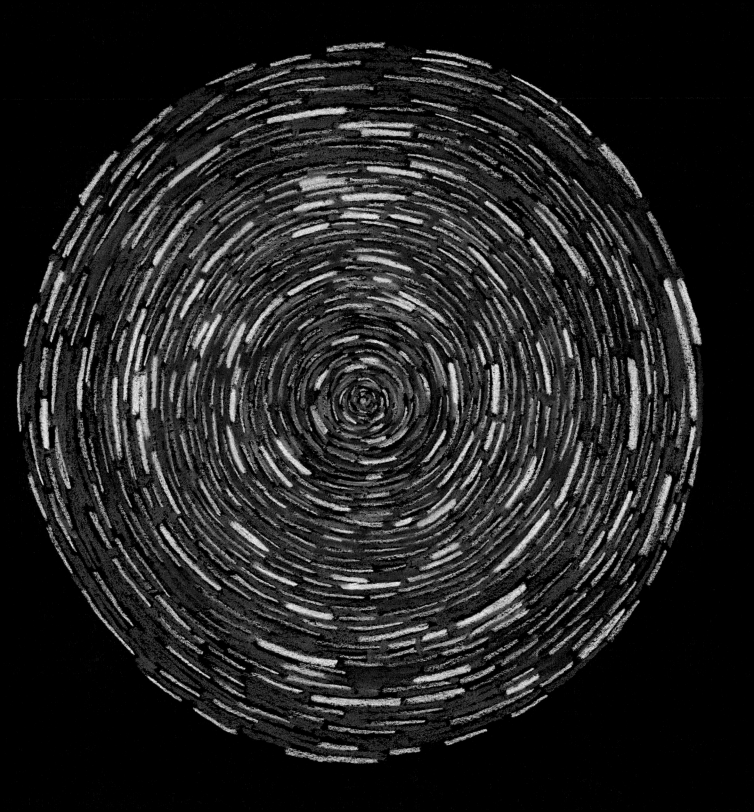

Don't you know I'm screaming inside?

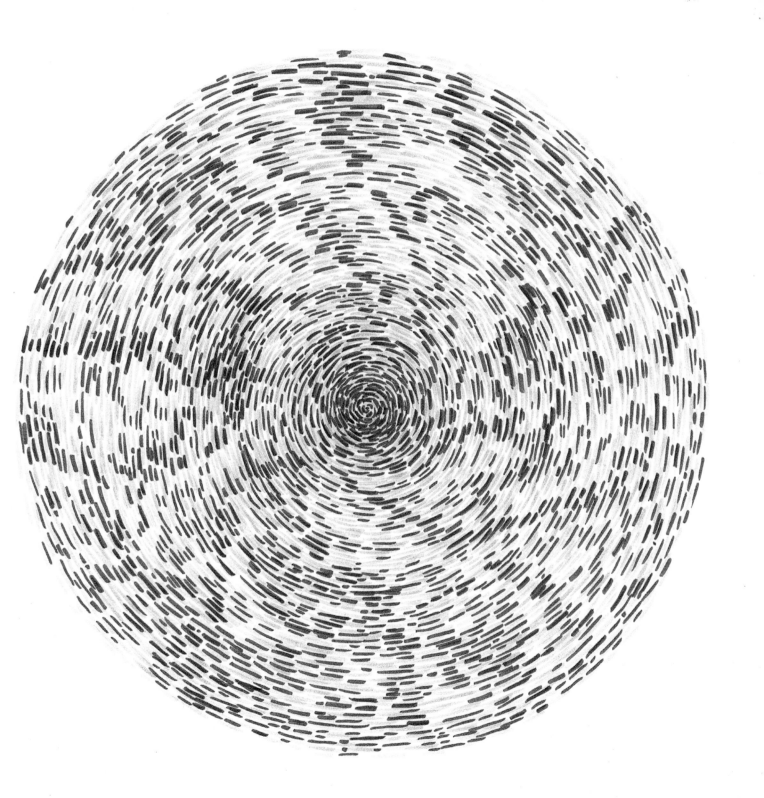

Screaming

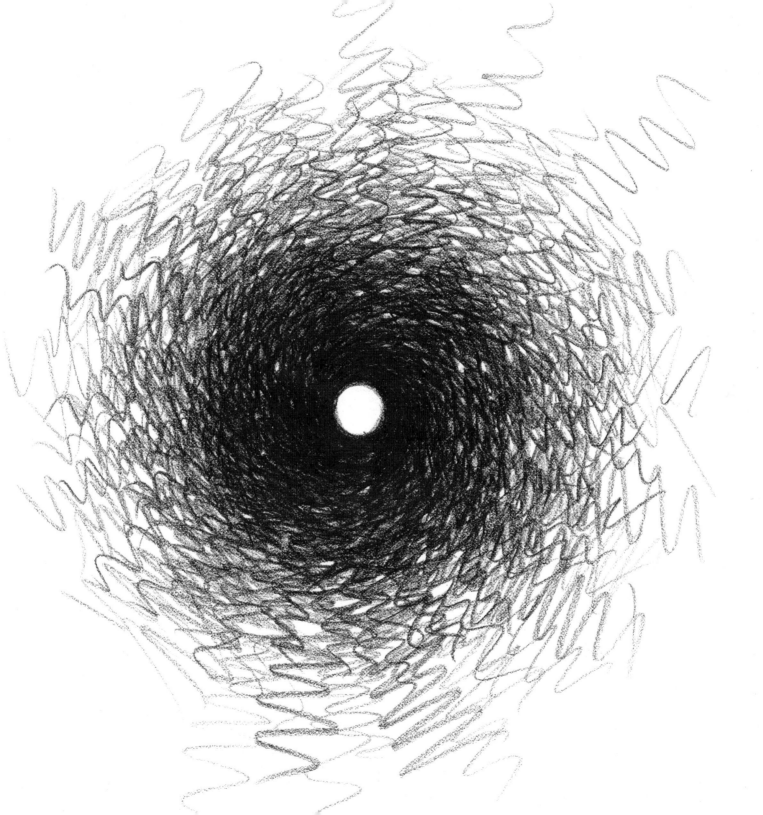

What's the matter with her?

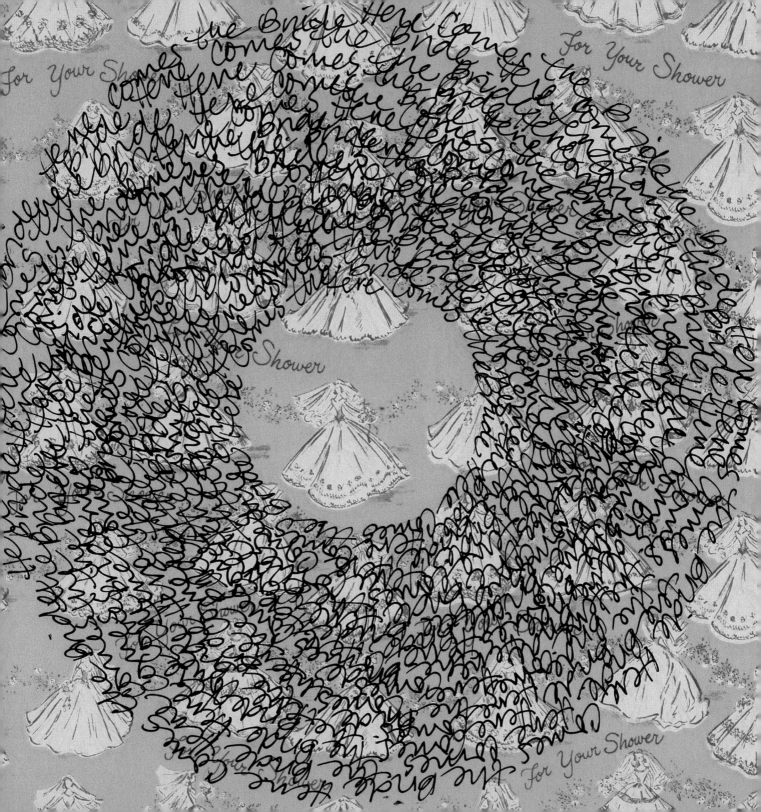

For Your Shower

For Your Shower

Shower

For Your Shower

CHAPEL OF LOVE

Words and Music by
PHIL SPECTOR, ELLIE GREENWICH
and JEFF BARRY

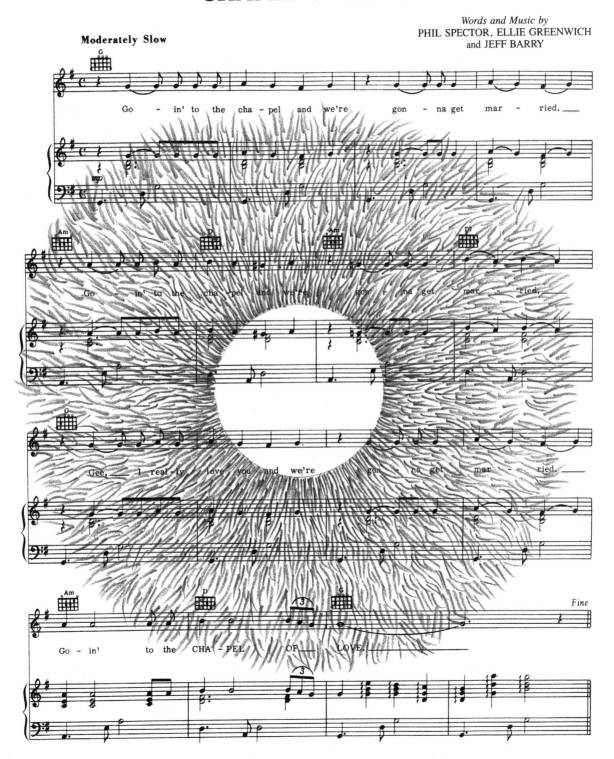

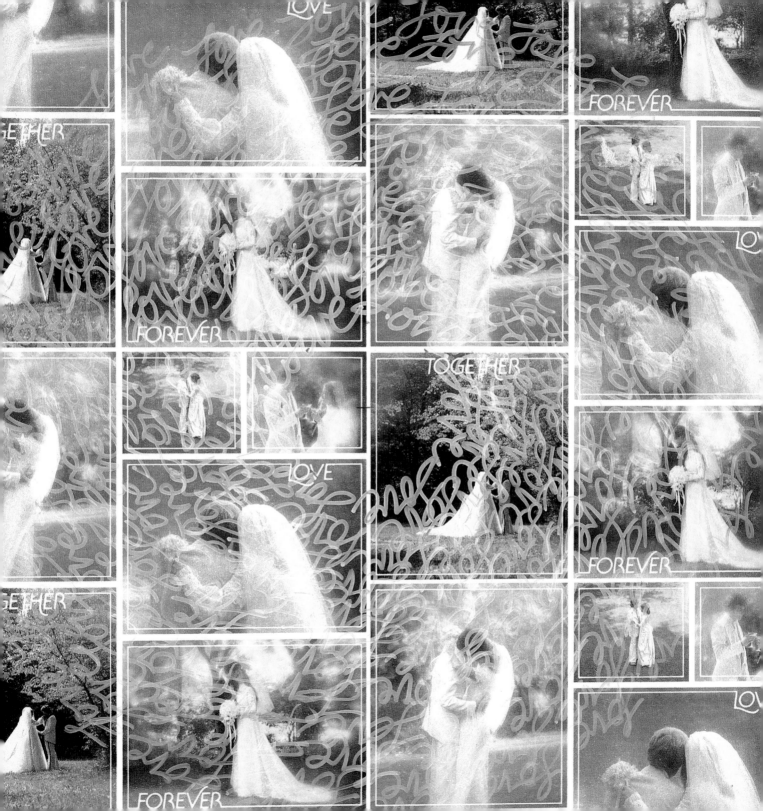

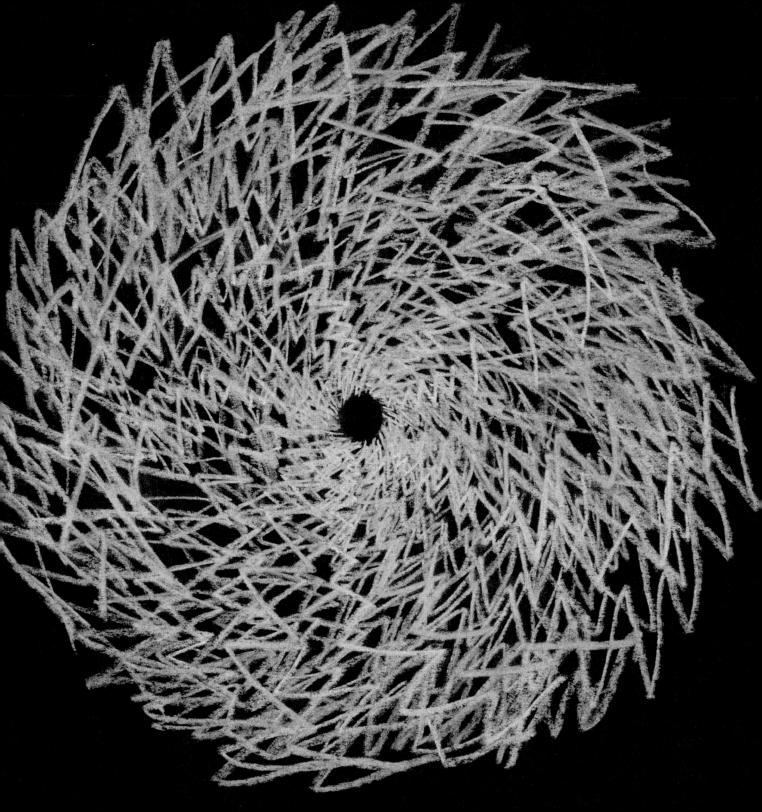

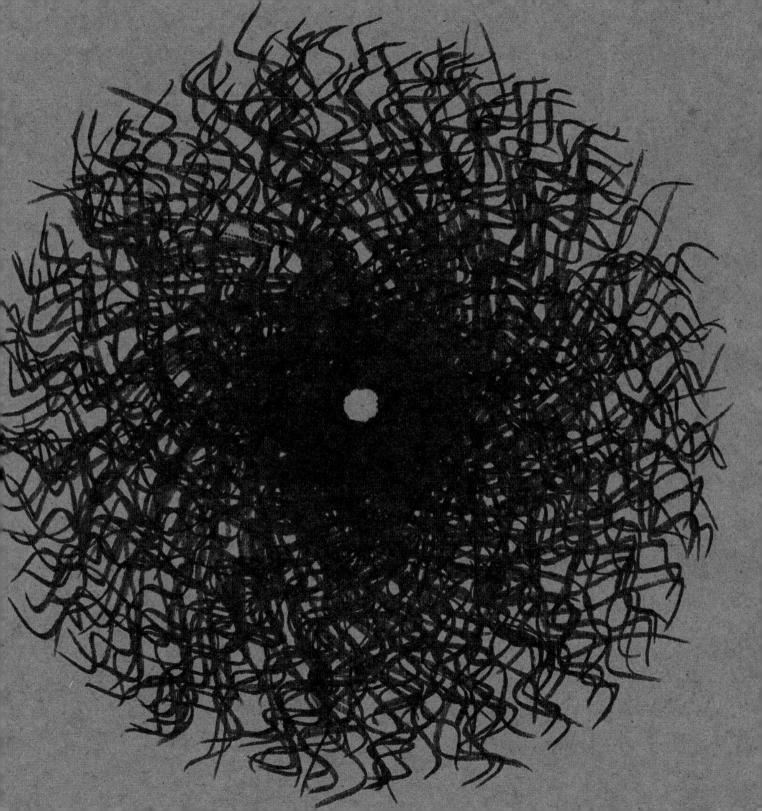

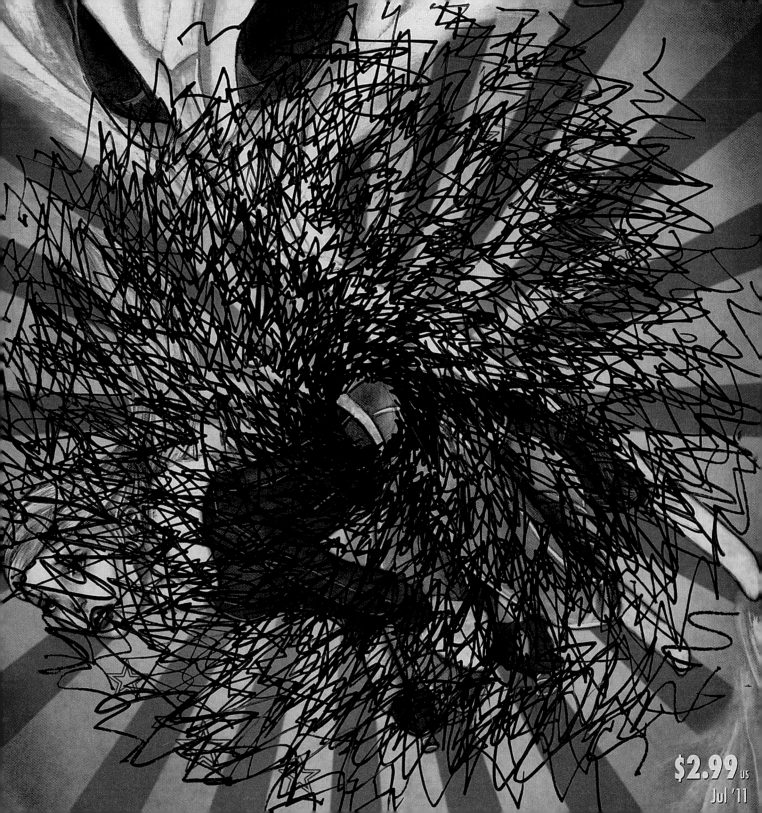

$2.99 us

Jul '11

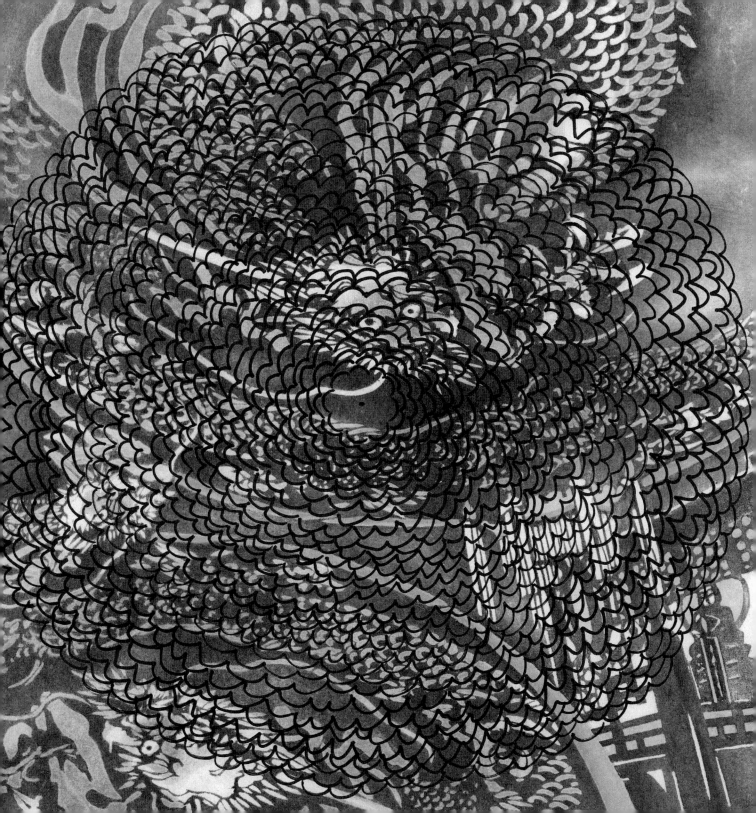

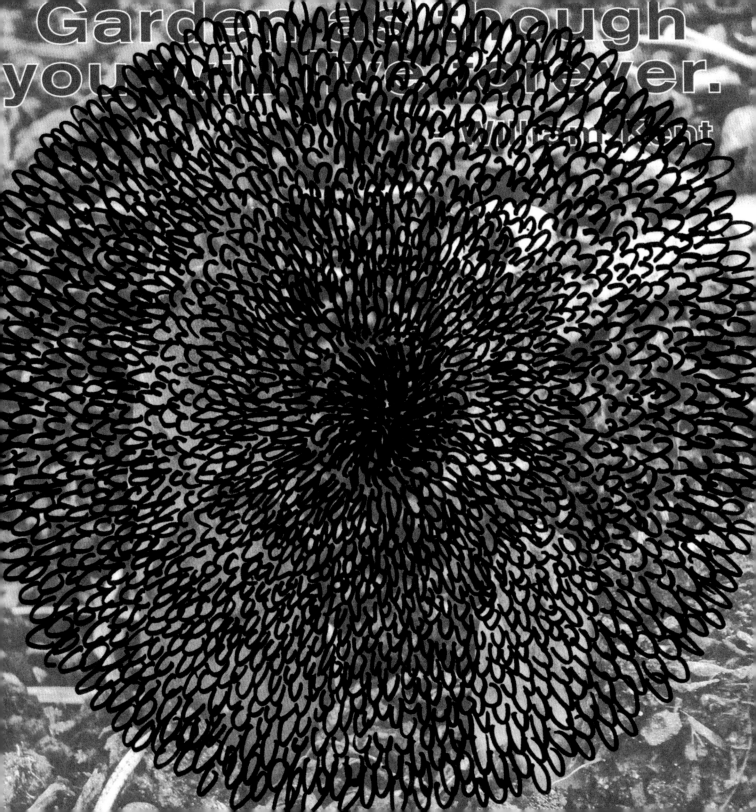

Garden as though you will live forever.

— William Kent

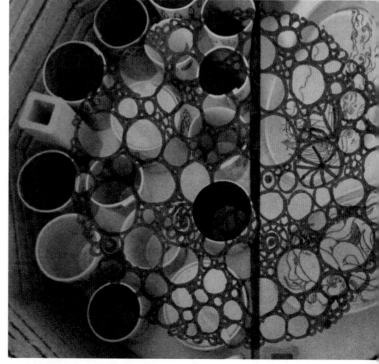

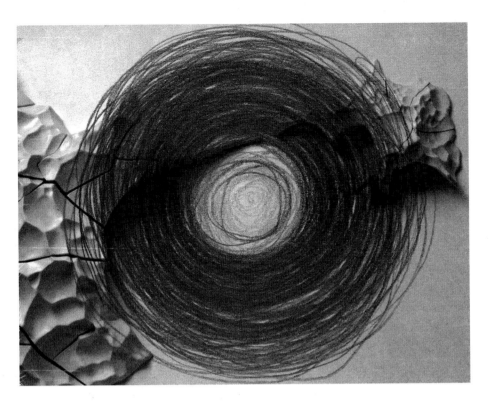

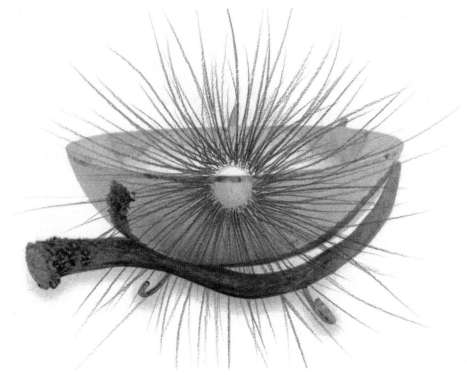

SPEAK WHEN YOU ARE
SPOKEN TO, DAMMIT!!!

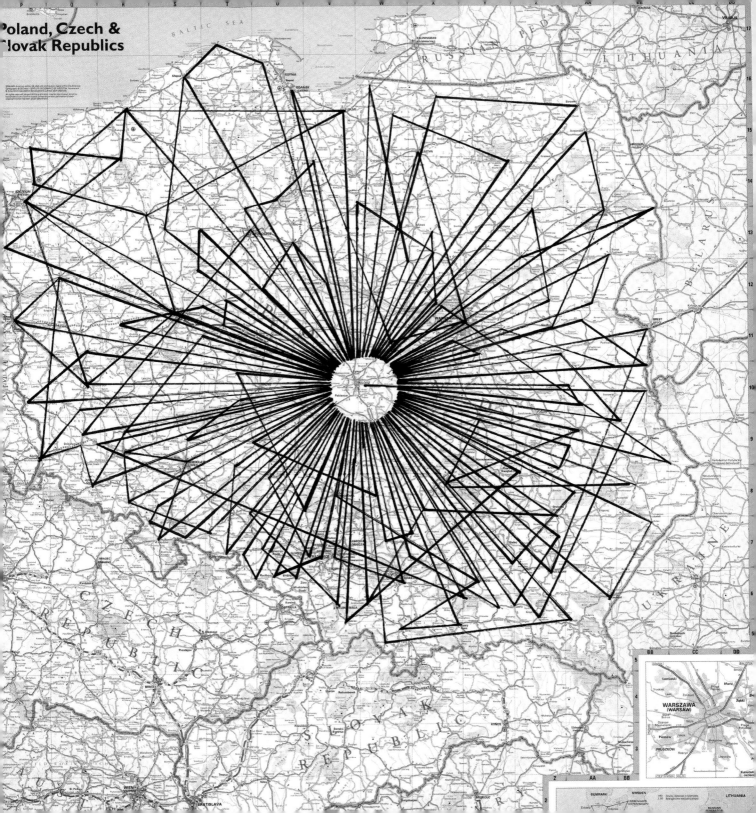

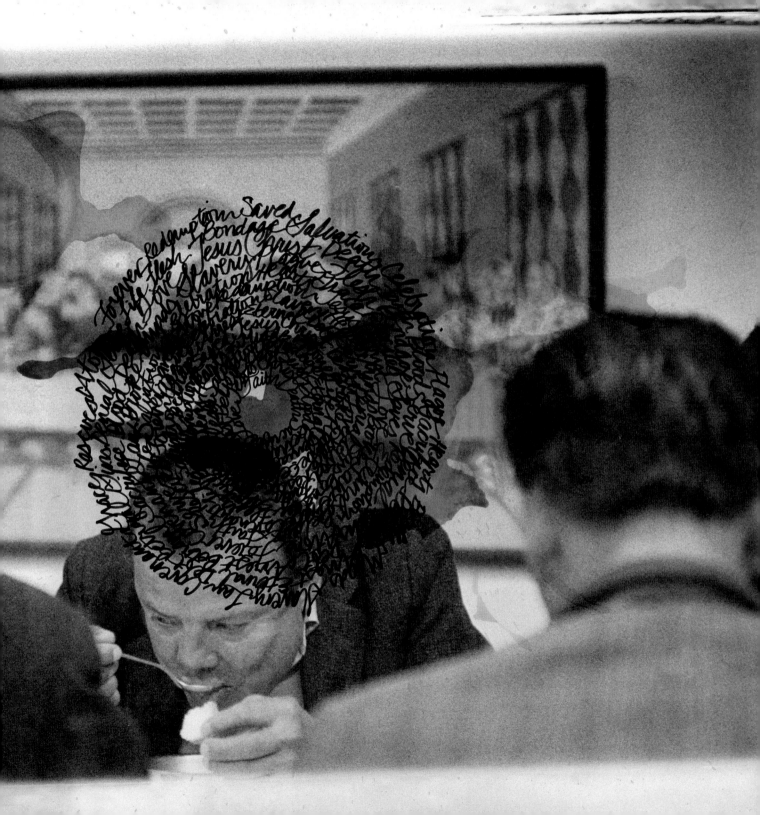

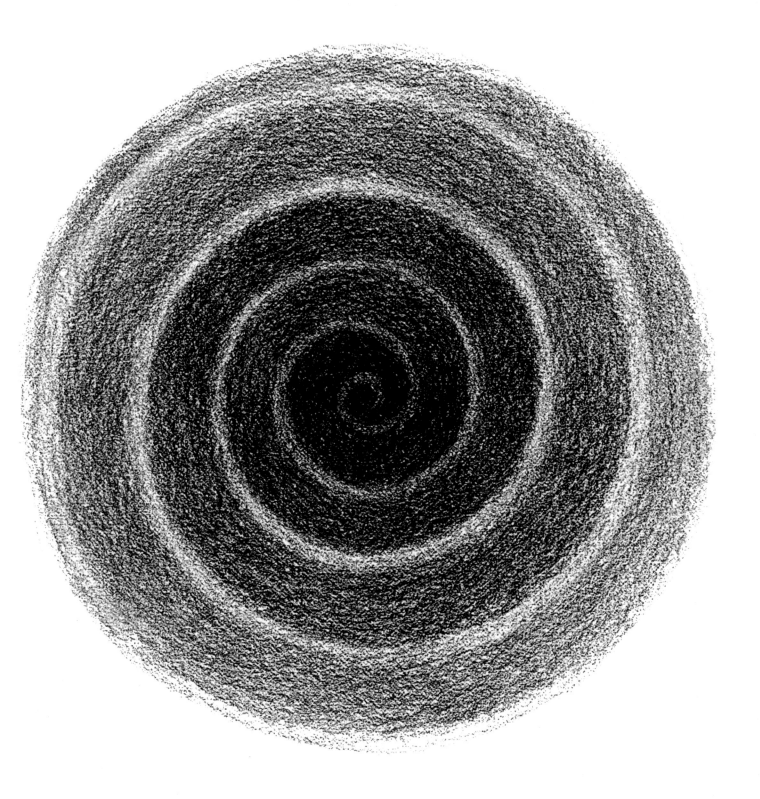

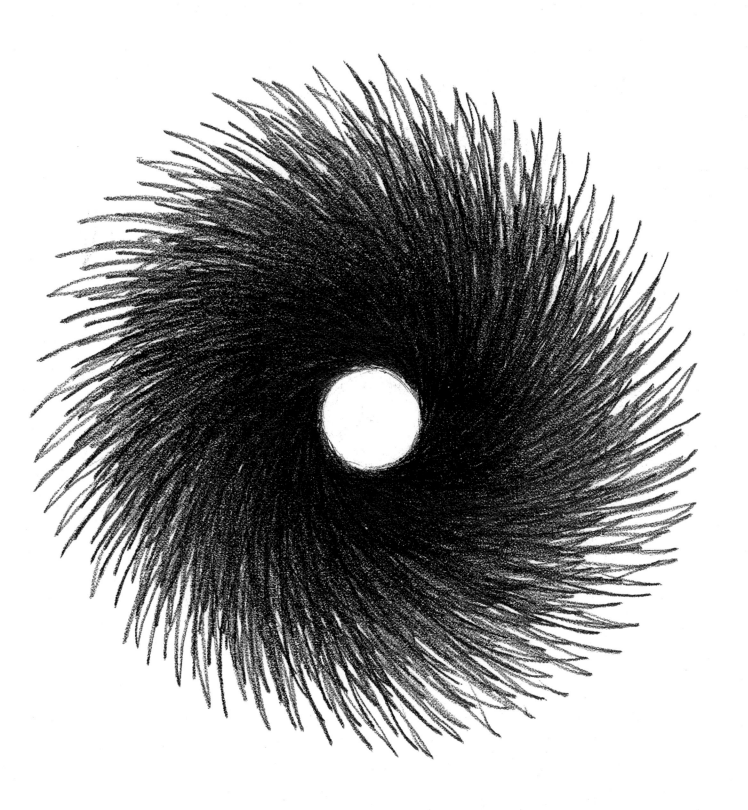

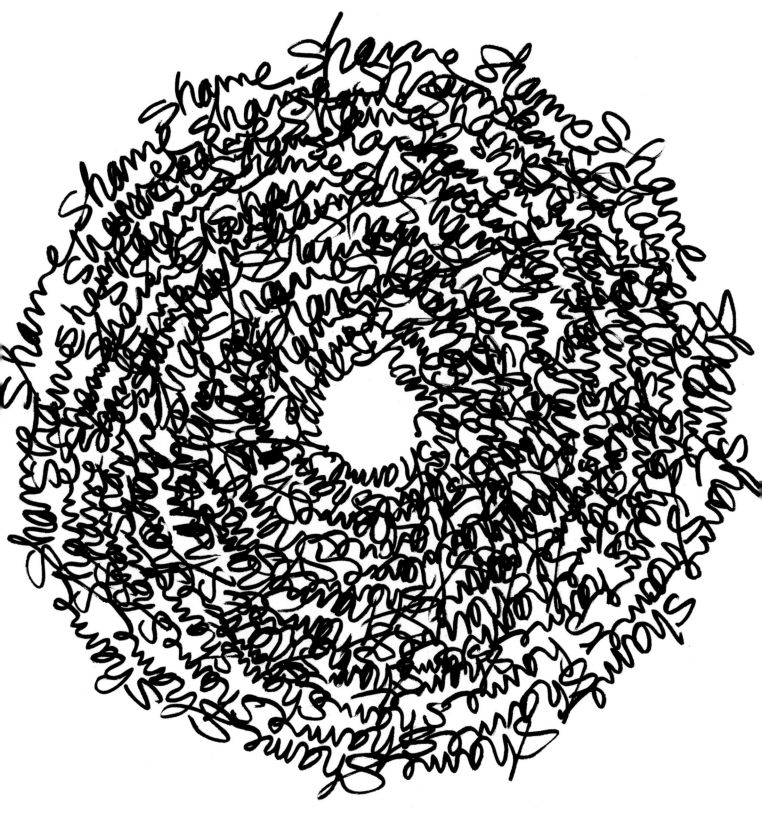

I'm bad
I'm stupid
I'm an idiot

My choices define me

I made bad choices
I made stupid choices
I made dumb choices

Our choices define us

choices I made stupid choices I made dumb choices I made dumb choice made dumb dumb choices I made dumb choices I made dumb choices I made dumb choices I made stupid choices I made dumb choices stupid define me my choices define me choices define me my choices define me made bad choices I made stupid choices my choices define me Our choices define me Our choices define Our choices define me stupid choices made choices define me

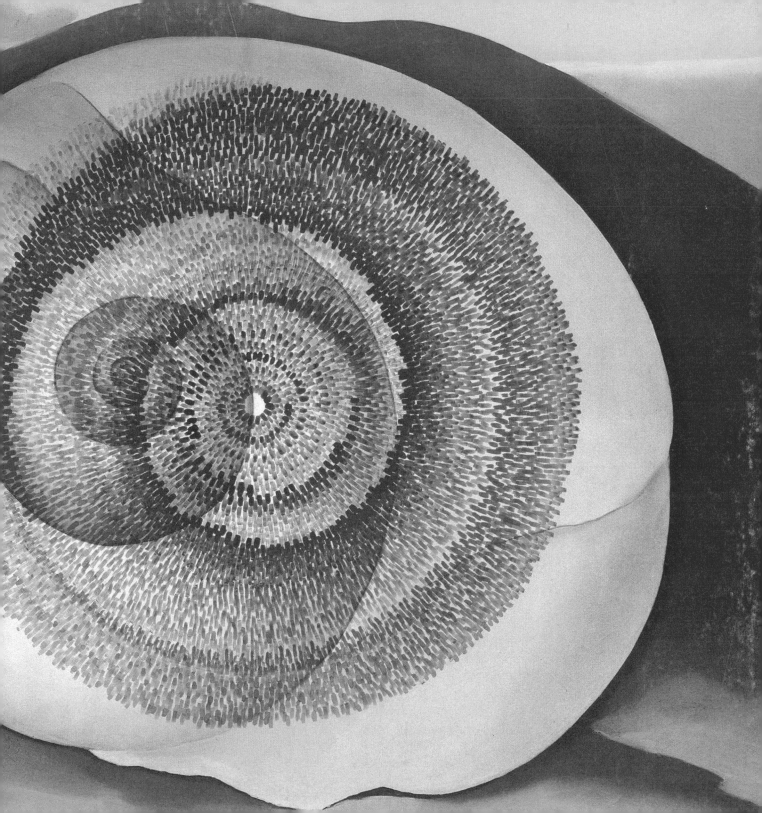

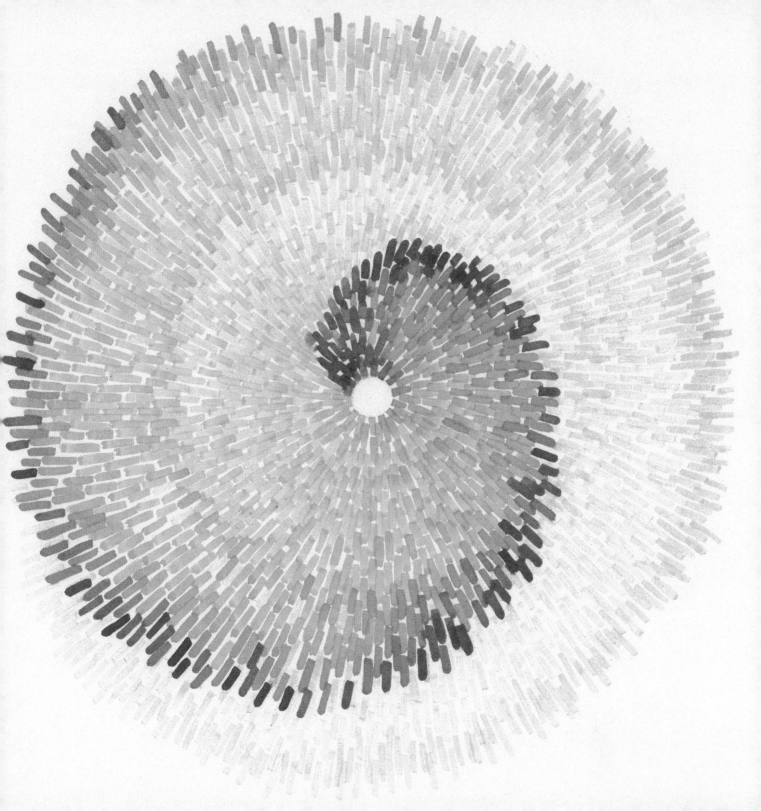

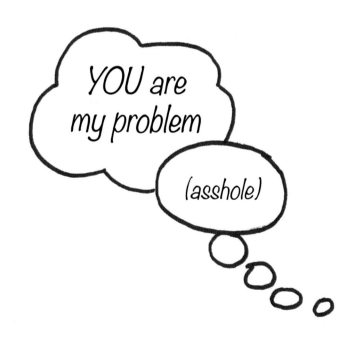

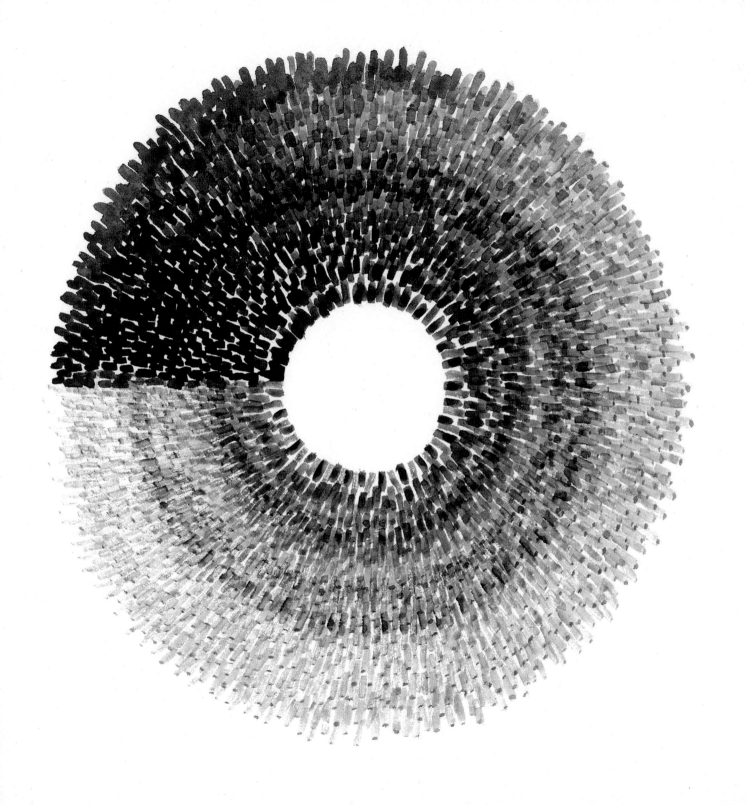

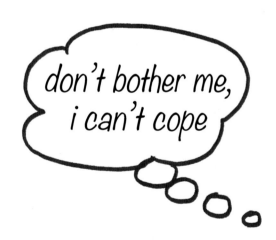

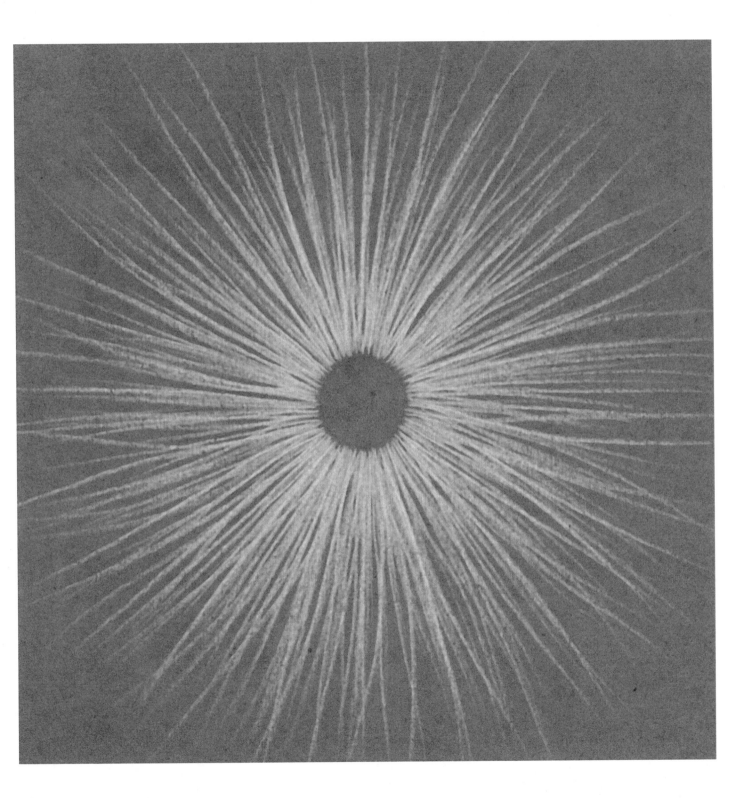

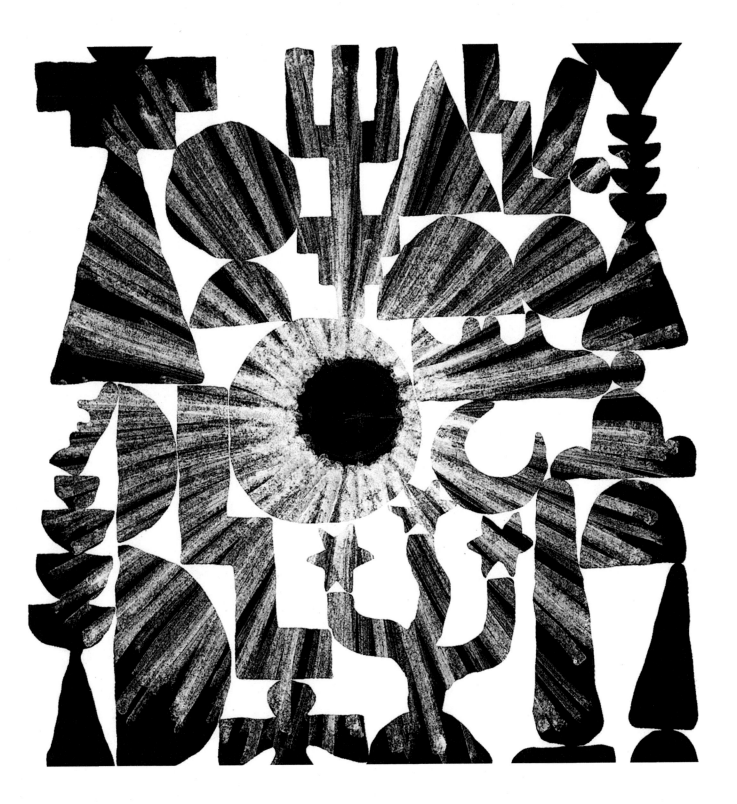

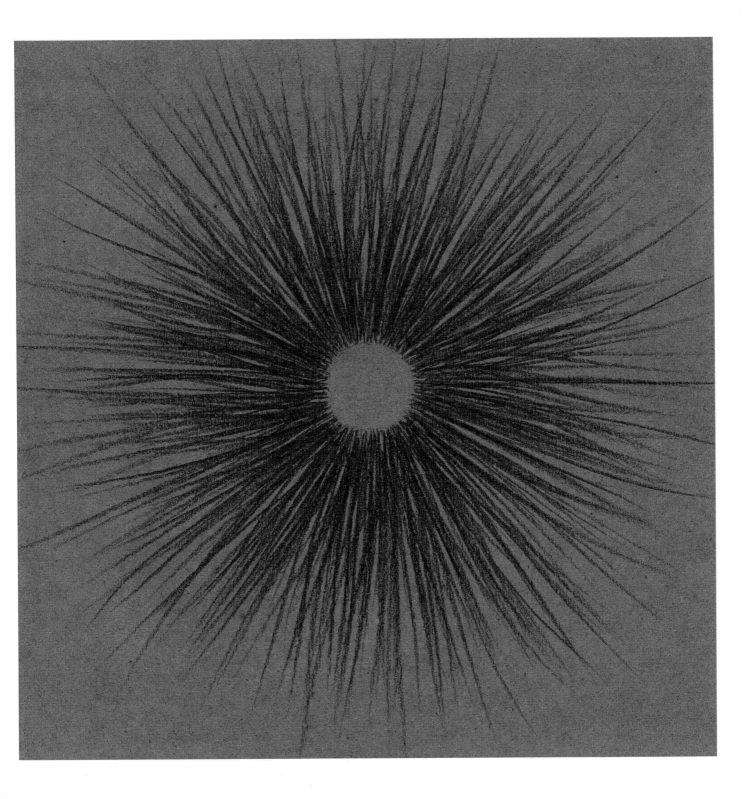

I won't speak
I can't speak

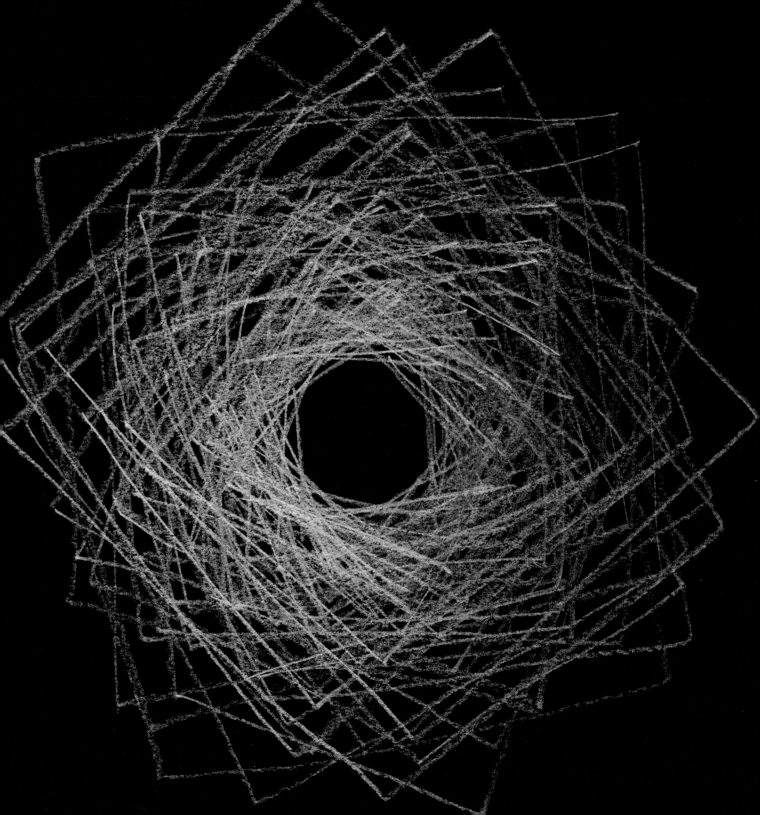

I can't,
Even if I wanted to,
Even if I tried,
Even when I tried

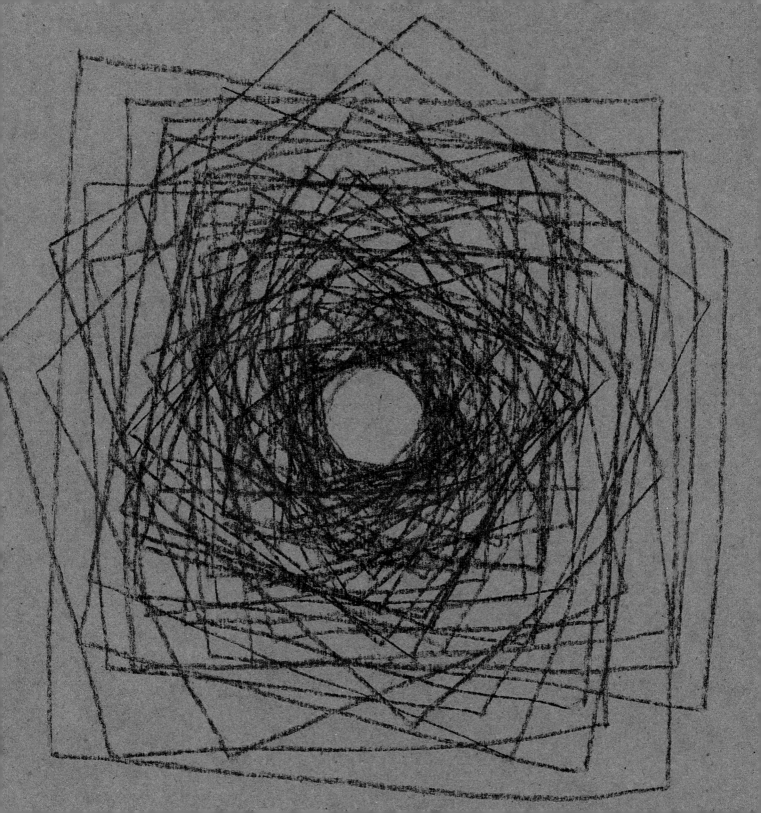

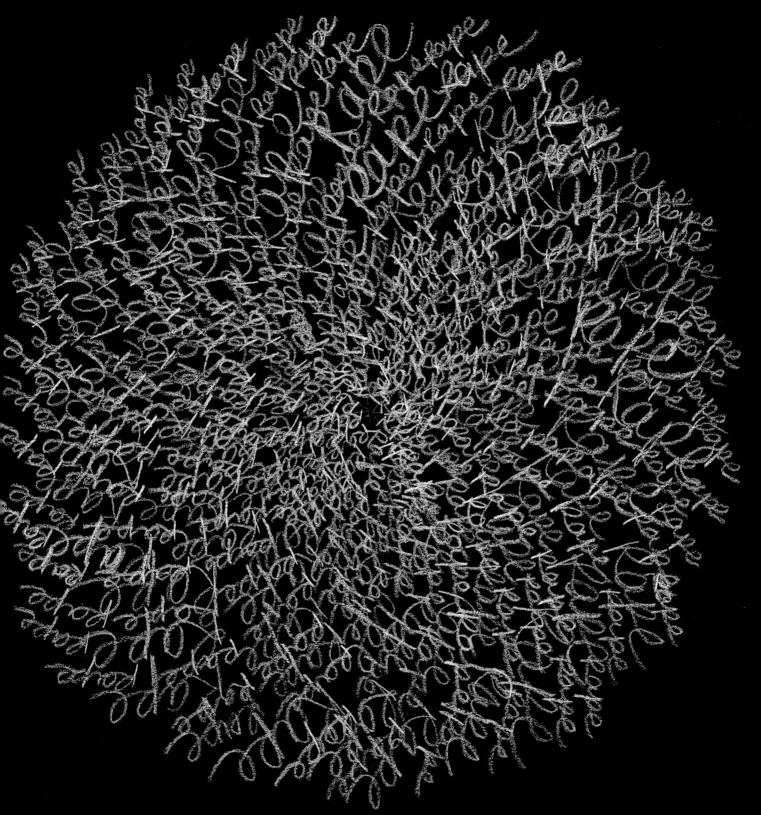

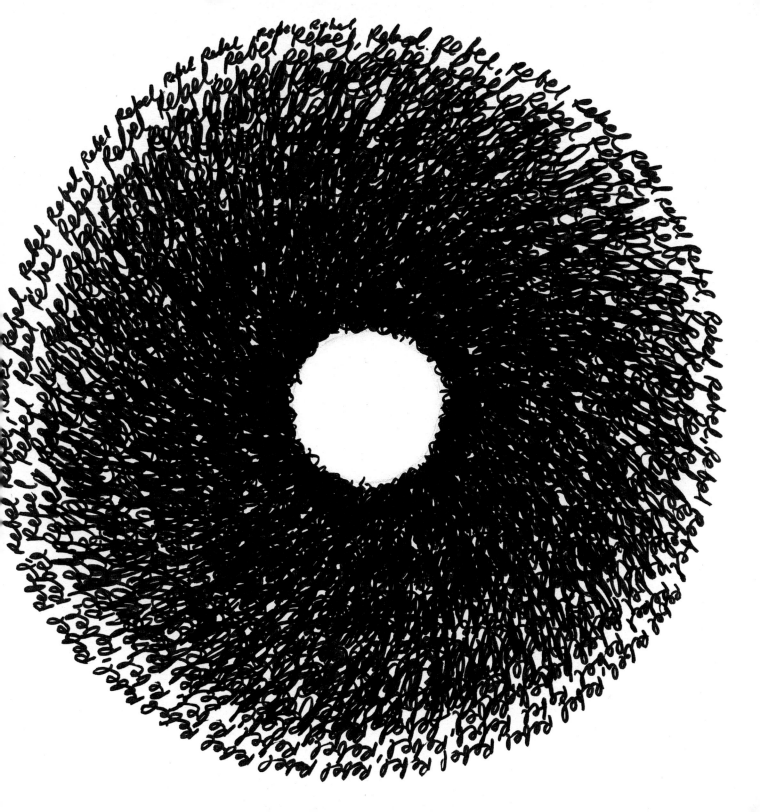

Screaming
I'm screaming
I'm screaming inside
Can't you see?
Can't you see me?
Can't you see me screaming?
Can't you see me screaming inside?
Can't you hear?
Can't you hear me?
Can't you hear me screaming?
Can't you hear me screaming inside?
Don't you know?
Don't you know me?
Don't you know I'm screaming?
Don't you know I'm screaming inside?
Screaming

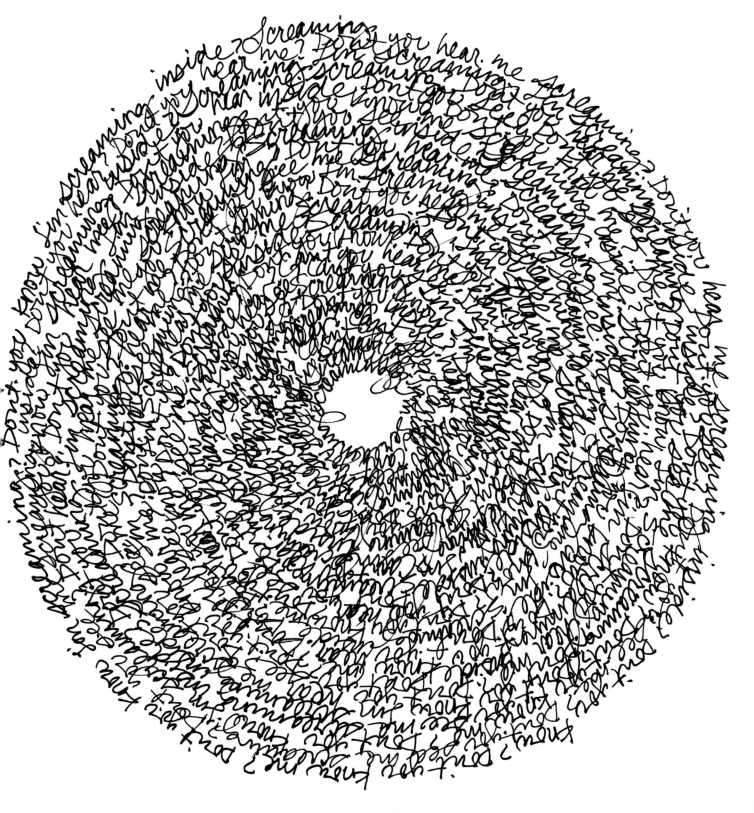

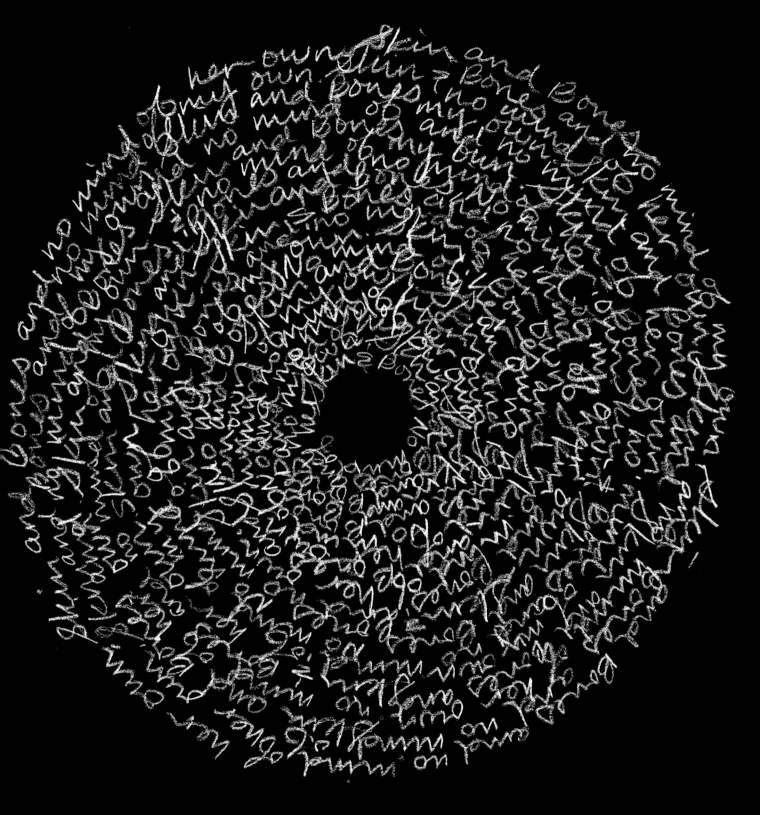

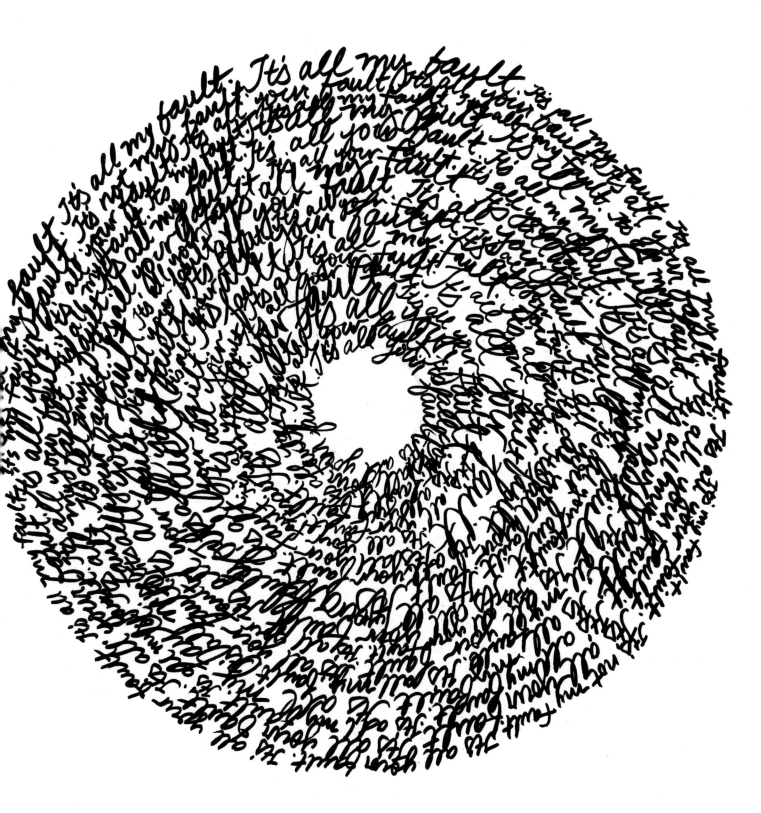

My mistake
My mistakes
My mistakes are fatal
Not all mistakes are fatal
All mistakes are fatal

There are no fatal mistakes

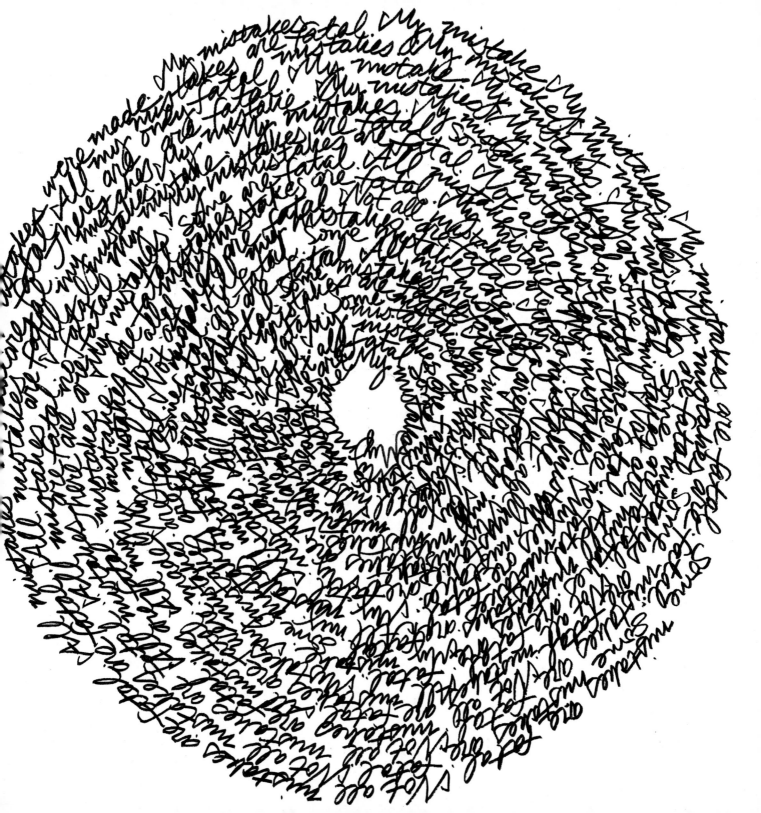

my (shameful) story

I was born in 1960. Between the ages of 4 and 7, I was repeatedly sexually abused by my father's best friend, Gene Hartman. Several years later, Gene killed himself. Shortly after his death, I received a call from Gene's wife, Eleanor. *He's dead*, she said, *and it's all your fault.*

Childhood sexual abuse is a prison without bars. It has lurked in the shadows of every important decision I've made throughout my life, both the good as well as the bad. It became the lens through which I misjudged others, the source of mistrust, the wellspring of shame.

I was tormented by this secret – my life diminished by its power. There was no action I needed to take to be inadequate, wrong or miserable; I just was. I was violated, ashamed, stigmatized, and filled with self-doubt and contempt. I have a term for describing my suffering – going into the abyss. It's a place where I spin uncontrollably in a cycle of self-loathing, depression and dissociation. I tend to go there when I feel ashamed. Though my life is now more joyful than sad, more purposeful than simply surviving, still, even today, the abyss – and all that it stands for – haunts me.

This book represents what an abyss feels like to me, how my head is filled with these omnipresent messages, while outwardly I'm like stone.

what is yours?

acknowledgments

(for Ms. Abramson's project 50yrslater.com)

I held onto a shameful secret for most of my life. I told just a handful of people, rarely publicly – until recently, that is. Allowing the darkness that I struggled with for decades to finally be exposed and embraced has given me unforeseen strength and resilience.

This project began as a vital element of an ongoing and more expansive effort to explore the realm of trauma (specifically, the long-term impact of child sexual abuse) through artistic means. It then took over my life. I created an *Abyss* daily, sometimes more. This book is the result.

Along this journey I've met many extraordinary people. Taking the time to reflect upon these encounters has given me tremendous insights and courage. I now want to thank the following people:

I thank Meg Garvin, J.D., Executive Director of the National Crime Victim Law Institute, for her kindness, empathy and support for the choice I made to use my voice as an advocate for victims and to use my art to embody trauma; Sigríður Björnsdóttir, co-founder of Blatt afram, Reykjavik, Iceland, for convincing me that my art and personal story truly matter – in the most inspirational way – to other victims; and Erika Rowell, Director of Programs, Darkness to Light, for recognizing how I have effectively transformed my suffering into something that can have a positive impact on other survivors.

In addition, I thank Gerður Kristný, winner of the Icelandic Journalism and Literature Awards, for her excellent advice to keep it simple – the brilliance of a few strong words – and her reassurance that my work is valuable. Also, the Icelandic artist Sigga Björg Sigurðardóttir, the Icelandic writer/artist Kristín Eiríksdóttir, and Dr. Sólveig Anna Bóasdóttir, a Professor of Theology and Religious Studies, the University of Iceland, all offered much encouragement.

I also thank Dr. Bernet Elzinga, Professor of Stress-Related Psychopathology, and Dr. Lenneke Alink, Professor of Forensic Family Studies – both of whom are co-founders of the Child Abuse and Neglect minor program, Leiden University, for acknowledging the power of my artistic visualization of trauma; and Dr. Iva Bicanic, a clinical psychologist at the Sexual Violence Center at the University Medical Center Utrecht, and Head of the National Psychotrauma Center, the Netherlands, for affirming that my wide-ranging efforts are helping many people – from survivors to professionals.

Additionally, I thank Elyn Saks, Orrin B. Evans Professor of Law, Psychology, and Psychiatry and the Behavioral Sciences, University of Southern California, for reminding me that *owning your truth* is a very powerful weapon in the fight against stigma; and Dr. Gregory A. Miller, Distinguished Professor and Chair, Department of Psychology, University of California, Los Angeles, for pointing out that I both host the abyss (dissociation/disconnection) as well as the creativity, the connectivity, and the generativity to express it.

I also want to thank Neely Shearer, founder of In Heroes We Trust, for believing in my vision and supporting my art; Bianca Sapetto, choreographer & performer, for noting the value in my struggle and the necessity for me to tell my story; Ellen Baird, editor of *Howl*, Joshua Tree, California, for seeing the beauty in my work; and Dr. Bérénice K. Schramm, legal philosopher, Cédim, Université du Québec à Montréal (UQÀM), for commenting on the power of my writing and art.

In addition, I thank Richard Ross, photographer and Professor of Art, University of California, Santa Barbara, for providing essential early feedback on the presentation of my work; and Karen Finley, performance artist, musician, poet, and Professor of Art, NYU Tisch School of the Arts, for reminding me of my courage.

Special thanks also go to Kerry Naughton, Executive Director of Oregon Abuse Advocates and Survivors in Service; and Svava Brooks founder of Educate4Change.

I want to give particular thanks to Catherine Ross J.D., Professor of Law, George Washington University Law School; Susan Karamanian, J.D., Associate Dean for International and Comparative Legal Studies, George Washington Law School; and Joan Meier, J.D., Legal Director, Domestic Violence Legal Empowerment and Appeals Project, Washington, D.C., for repeatedly assuring me, in the most laudatory terms, that my story is worth telling.

Thanks as well go to my copy editor, Vici Casana.

My heartfelt gratitude also goes to my publisher, Asylum 4 Renegades Press, who believed in my artistic vision, and gave its infinite support throughout the entire process of creating and producing this book.

And lastly, I give thanks to my magnificent family – my daughter, two stepdaughters, and husband – who each in their own way have shone a light (or perhaps a beacon), to help me find my path, thereby making my life – both the joys and sorrows – fully worth it.

afterword

Shame.
Insidious comes to mind.
Relentless too.
Scathed beyond remorse and recognition,
and needlessly triggered by innuendo and allusion.
An eternal muddling of impropriety and atrocity
that's void of deliverance,
except perhaps as an abyss,
which is no escape at all.

Dr. Paul R. Abramson
Department of Psychology, UCLA

artwork

author

Tania Love Abramson, MFA, is a conceptually focused artist, lecturer, writer and performer. Drawing on her life story, her art delves into the elusive psychological manifestations of trauma, and the potential for resilience in its aftermath.

 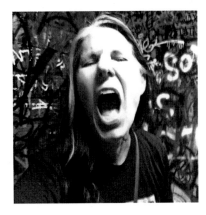

photo credits (left to right, top to bottom): Paul R. Abramson, Elizabeth Folk, Ian Putnam, Tania Love Abramson